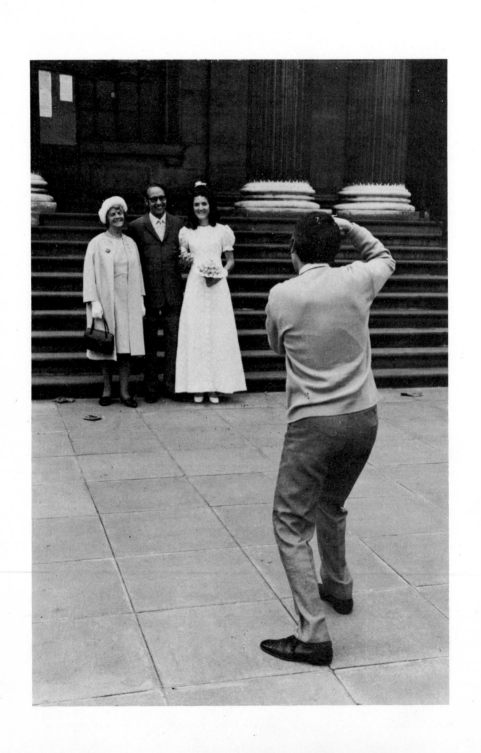

How We Are

A book of photographs in six sections by Euan Duff

With an introduction by John Berger

Allen Lane The Penguin Press

Copyright © Euan Duff, 1971
Introduction copyright © John Berger, 1971

Allen Lane The Penguin Press
Vigo Street, London W1

ISBN 0 7139 0253 1

Printed Offset Litho in Great Britain by
Cox & Wyman Ltd, London, Fakenham and Reading

Set in Monotype Modern No. 1

Introduction

The institution of monogamous marriage is primarily a property contract. It is one of the guarantees for the continuity of private property. Through the rites (or romance) of marriage, notions about the sacredness of property lose their economic reality and are disguised as longings of the soul. The sacredness of marriage is said to be based on the sacredness of love. Meanwhile the state, the landlords, salesmen, hire-purchase companies, building societies, advertisers, wait . . .

Romantic sexual love, when reciprocal, offers, however briefly, an experience of freedom and so of happiness which is extraordinary even to observe from the outside. Regardless of how sentimentally this happiness may be explained, it is noble – because each self wishes to go beyond itself and become reciprocal with the other. Such is the effect on the human imagination of sexual passion, whether it lasts for hours or years.

At weddings, if they are not marriages of some kind of convenience, most people are aware of these two conflicting aspects of the situation. The conflict gives the occasion of the wedding its peculiar tension. The wedding guests may not formulate the conflict in the abstract and distant way in which I have done. But their awareness of it is often evident in the expression on their faces. Not always in each individual face – but in the ensemble of faces. They smile. Many kinds of smiles. Smiles to hide doubt. Smiles to encourage hope. Smiles of complicity. Smiles of envy (Wedding Night!) Sceptical smiles, polite ones, obligatory ones. The bride may smile, rapt, careless. And her mother will smile to see her smiling like that. Look at one of the first photographs in the book which follows and you will see. But no smile except the bride's is complete. Behind them all are calculations provoked by the flagrant inevitable disparity between the wedding contract and the passion. The two are, in their deepest nature, incommensurate. How can it turn out? If it lasts, on what terms? If it doesn't? Yet nobody envisages an alternative. It happens eventually to nearly everybody. The celebration of the sexual union of a young couple must entail (and especially for the woman for she may have children) the forfeiture, in principle, of a life's independence! Yet the deep unnaturalness of the arrangement prevents people believing in it wholeheartedly. Until the wedding guests begin to drink they are sceptical. Either they bide their time, or, if they are by nature optimistic, they hope against hope.

This is how I myself read the first few photographs in Euan Duff's book. I could continue. But Duff envisaged a book without a text, a book whose meaning should be established by the sequence of his photographs and by nothing else. His book begins after these pages of writing end. Meanwhile I will interpret no more, but simply try to analyse why his photographs impress me.

It has often been said that no good photograph requires a caption. This is because, in principle, such a photograph makes its point unambiguously. The photograph itself demonstrates why the photographer chose to take a picture at exactly that moment. It was a moment when what was visible made sense of itself. The peasant in Asia was falling, having been shot. The horse in Dublin was drinking at the trough. As she entered the plane, she turned round to smile at the journalists. The sense the picture makes usually fits into a scheme of thinking or feeling about the world which we already possess. There are exceptions to this general rule – photographs which are deliberately incongruous or surprising. But normally photographs confirm our knowledge of the world. A photograph which preserves the original uniqueness of the event or person it depicts is very rare. Some of the portraits of Walker Evans are examples of this rare achievement. It will be interesting to remember later that Walker Evans is a photographer whom Euan Duff particularly admires.

What I am suggesting above is that when a photograph makes its point so unambiguously that it requires no caption, the point has as much to do with an agreement between photographer and viewer as with the subject-in-itself. To some degree the point is imposed upon the subject – but imposed of course in a way that is peculiar to photography. The photographer selects from an infinity of possible aspects and moments one particular aspect and moment. And it is by this choice that he can impose his own meaning, his own point, upon the independent life of the subject. The subject becomes *his* subject. This process can be observed at its most brilliant in the work of Cartier-Bresson, precisely because in this ability to see and select he is the greatest photographer ever. The moment he selects is nearly always a moment when the subject appears to reveal its true nature. The raconteur in the café holds his audience in maximum suspense. The engine-driver takes off his goggles as his train draws into the terminus. One judge whispers to another what has been on his mind throughout the trial. Cartier-Bresson convinces us that the moment he has chosen is the moment of truth; he has seen behind the social mask; he has distinguished between nominal roles and true ones. What Daumier did by imagining he has done by seizing the instant.

I admire such photography and I am aware of how much it has contributed to my mental imagery. But like every other possible approach, it has its limitations and it is necessary to be aware of them. The limitations of this kind of photography (which has supplied the norms for all pictorial social reportage) is that it tends to present people *univocally*; the multiplicity of their possible roles or moods or meanings is reduced to the one which fits the point of the photograph.

To appreciate the truth of this, consider the many press photographs of victims of the Nazi concentration camps. These images accuse us. We react to this accusation according to our opinions. Some may think: 'It could have happened to us.' But on the evidence of these photographs nobody is led to think: 'They were exactly like us.' The single point being made is their difference from us.

There is another very common type of photograph, which is in many ways the opposite of the news or reportage picture which I have been analysing. This is the family snap taken on a beach, at a wedding, during a picnic. Because such photographs are taken for the family and a few friends, there is no need for the photograph to make its point clearly and unambiguously; its meaning is implicit in the occasion. That is Mother on the beach. There was no need to choose the moment of truth. We know it is her, last August, and we know many other things about her. No single meaning has to be imposed; many meanings are invoked by the simple fact of her recognizability. She may have collaborated in the photograph, arranging her hair beforehand and then smiling at the camera. But the photograph does not necessarily stand or fall by the quality of any prepared or spontaneous moment.

The function of the family snapshot, which speaks to a dozen people, is so different from that of a published photograph that it may seem absurd to compare them at all. Yet in photography the distinction between the public and the private domain is not as absolute as one might think. (This is the great difference between the painted and the photographic portrait: all painted portraits were inevitably public.) A snapshot reproduced in a biography retains its private character but serves a public function.

The specific quality of a family snap derives from the fact that it does not have to make a point of its subject. Consequently in most cases the photograph is totally without interest unless you happen to know the family. But occasionally, very rarely, such a photograph can reveal in an uncanny way, even to a stranger, the extraordinary complexity of the scene and people it depicts. And when this happens, you, who are looking at the photograph, enter into its time which seems to be still continuing; whereas public photographs, with their instantaneous meaning, always deliver their arrested moments into your time, the continuous time which the clocks keep.

Euan Duff is a highly conscious professional photographer. There is no question of his being an amateur. Yet it seems to me that, for reasons similar to those I have just given, he often tries to produce photographs whose essential character

is as near to that of the family snap as to that of public reportage. Often, I say; not always. There are photographs of his which belong unequivocally to the reportage tradition. Sometimes when he tries to come close to the family snap, he succeeds, and then the scene and its time acquire the complex, haunting quality I have described. Occasionally he fails and produces photographs which are of no interest at all to the outsider.

Both the richness of his work and the initial difficulty of experiencing it (because its style is unfamiliar and undramatic) are the result of his deep suspicion of imposing any single meaning upon his subjects. He refuses to produce *conclusive* images. It is we who must draw the conclusions, and this we are unused to doing before photographs. At the same time, his refusal to take conclusive pictures allows him and us to get unusually near to the people he has photographed. This nearness has nothing to do with the illusion of physical nearness created by close-ups or a telescopic lens. It is the antithesis of the secret proximity experienced by the real or photographic voyeur. We experience a sense of nearness because the subject's view of him or herself has been left intact, and such a view of the self is what constitutes a very large part of any person's presence. The man, for example, proudly in the front garden of his house, called 'Pine Tops', beside his car. This picture, in the context of the book as a whole, refers perhaps to the consumer society, the alienation of the couple, the solitude of petty responsibilities in vast anonymous organizations; but it is also a picture which the man would like to have taken of himself, his garage, his garden, his daughter. This is a particularly striking example, but the same is true of all Duff's photographs, even when they are not entirely successful in other respects. There is not a person in this book whose presence has not been respected, who has been caricatured, whose view of himself has been violated. There is not a picture which has – metaphorically speaking – been *taken by force*.

Euan Duff and I may disagree about the moral basis for this scrupulous respect for other people. I think that for him it is the natural consequence of a profound, extensive humanism. For myself I am suspicious of any notion of humanism in a class society. So long as class exploits class, humanism, as I see it, is as remote a dream as the religion it is said to have replaced. But in face of the actual photographs our differences become unimportant, for it is Duff's moral scrupulousness towards his subjects which makes him capable of such subtle, pervasive 'portraiture'.

Euan Duff's dissatisfaction with the conclusive image and the univocal interpretation has led him to experiment with sequences of photographs. There are several kinds of sequences in this book. There are pictures of the same subject taken in quick succession one after the other. An outstanding example

are the pictures of the man in the pub, talking in order to enchant, to captivate the girl at his side. One might argue that a film or television sequence could deal with this subject 'in time' better. Yet it would deal with it in a very different way. Watching it, we would be awaiting the outcome. Our own experience of time would be continuous with the experience of time of the man in the pub with the girl. Whereas here it is discontinuous, and into this discontinuity, into its space, we can project the experience of other times. That is to say our view of the scene is more lucidly *comparative*.

Yet supposing – one might continue to argue – it was a sequence of 'stills' taken from a film, would this not constitute a more logical and suitable method? I doubt it. The fact that a film camera works *with* time instead of *across* it affects every one of its images, on both a technical and a metaphysical level. In a cinema 'still' you are always more aware of the intervention of the camera with its more rigorous technical requirements of space, repetition, lighting. The optic of the film camera is less immediate. Its lens is weaker. It takes twenty-five frames a second whilst a photographer in similar circumstances would be likely to use an exposure of one-sixtieth or one-hundredth of a second. Most important of all, the eye behind a film camera is looking for something absolutely different – for development instead of conjuncture.

Another kind of sequence which Duff uses consists of the reappearance of the same people at different points in the book. For example, the wife of the man with one leg. We see her in her sitting-room, coming home from shopping, laughing with her son, opening her front door, watching television. Such sequences offer us a chance of seeing different aspects of a life, different moods, different activities. But for me they do more than that. They change the subject of the photograph into a character – in the novelist's sense of the term. There is no explicit story, but the fundamental process of the novel, which is not the progression of the story but the process by which the reader comes to know the principal characters, this process is established in photographic terms. I find myself looking at each photograph of her in the light of the others, and then each of the others repeatedly again. In the end images of her, such as Duff has not photographed, form in my mind. I can imagine her when she is absent.

This kind of sequence also has a second, more general, meaning, less striking than the first, but necessary to the style of the book as a whole. Such sequences prevent the book acquiring a false sociological 'objectivity'. The book, without pretending to be comprehensive, nevertheless presents a synthetic image of a society – England in the late nineteen-sixties. The reappearance of certain characters reminds us that this society is made up of lived lives, and that each life constitutes the centre from which, for that person, everything else must be perceived.

Lastly, there is the sequence of the photographs on each page, of the pages themselves, and of the six chapters of the book. Clearly, Duff wants his book to be read sequentially and re-read. He wants it to be read and referred back to as though it were a Discourse. No photograph in this book is meant to be considered as self-sufficient. The project is an extremely ambitious one and, at the level at which Duff aims, it is unprecedented. It demands that the reader breaks with the habit of looking at photographs as single, simple, prepared statements. It demands that he himself makes the connections between the images – not in terms of a puzzle whose solution is to guess correctly what Duff meant, but in terms of the reader's own experience of society.

This is not to say that Duff meant nothing by the selection and arrangement of his photographs in a certain order. He wanted, by contrasts, by parallelisms, by the accumulation of images, to construct an overall image of social life as he sees it. Hence the title: *How We Are*. An overall image, but not a final conclusion, because the articulation of all the parts, which make up the whole, is governed by the connections which each individual viewer makes for himself.

Has Euan Duff succeeded in his enormously ambitious project? Not entirely. It may prove to be a life's work. It is easier to begin such a project than to end it. In the first three chapters the necessary latent tension between the images, the tension which prompts the viewer to make his own connections, is unfailingly there. In Chapter 4, after the photograph of the huckster in Leicester Square, it disappears. In the first half of Chapter 5 it reappears marvellously, and then slackens after the first wrestling picture. In Chapter 6 it is only partly re-established by the last photographs which compare the tantrums of children with the persistence or the resignation of the old.

Such are my reservations. I would like to repeat that I find the first three chapters extremely impressive. I can think of no comparable contemporary English work of literature or visual art which so gently, so persistently and so finally brings one face-to-face with the wretchedness of the kind of society in which we live: a society in which every personal meaning achieved by an individual is pitted against corporate meaninglessness; in which every personal need, expressed in terms of what is socially available, is in agonizing conflict with the origins of that need in the soul.

The problem is to experience these photographs for oneself, to make the connection between *how we are* and *how we could be*. This requires time, time spent within the book. The reading of the few previous pages is no substitute.

January 1971 John Berger

Acknowledgements

Photographing people behaving naturally is always an intrusion into their lives. Some of the following pictures were taken with the subject's permission whilst others were taken more casually in the street.

I have only used a small proportion of my work in this book and many people who allowed me to photograph them do not in fact appear. I would like to say how grateful I am to everyone who let me photograph them, and particularly to those who allowed me to spend long periods of time with them or their families photographing the more personal aspects of their work or their home life.

Euan Duff

1

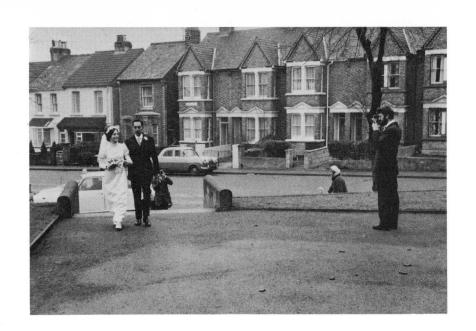

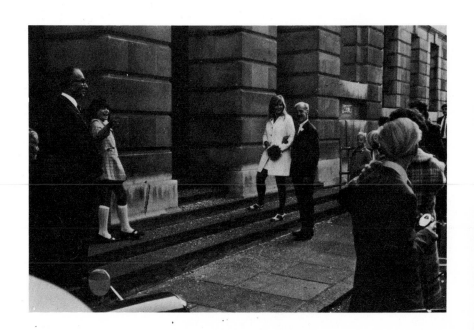

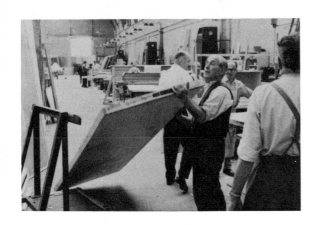

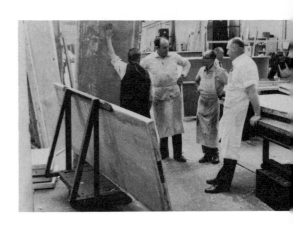

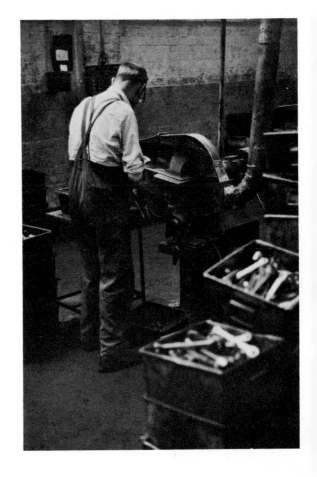

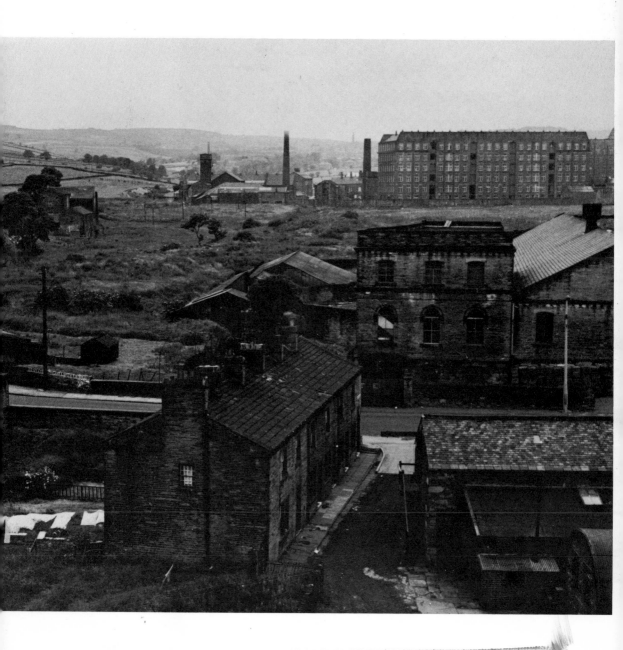

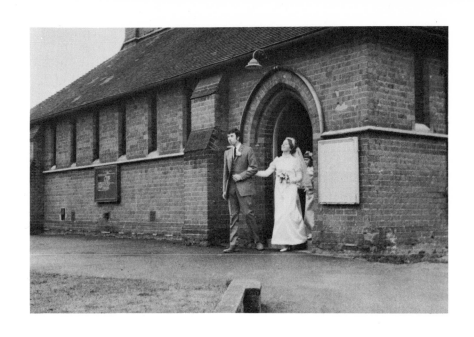

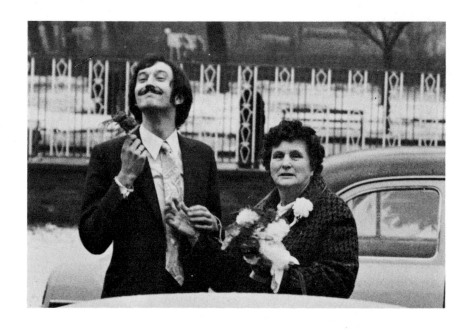

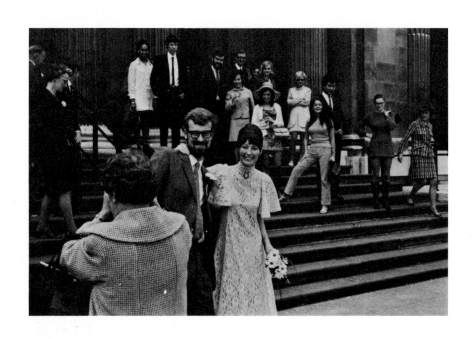

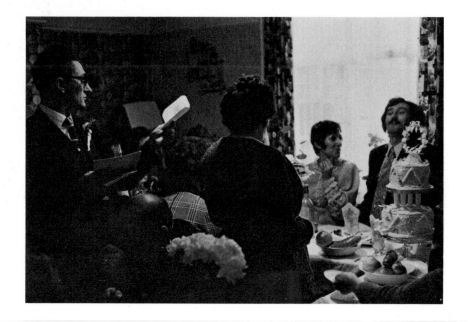

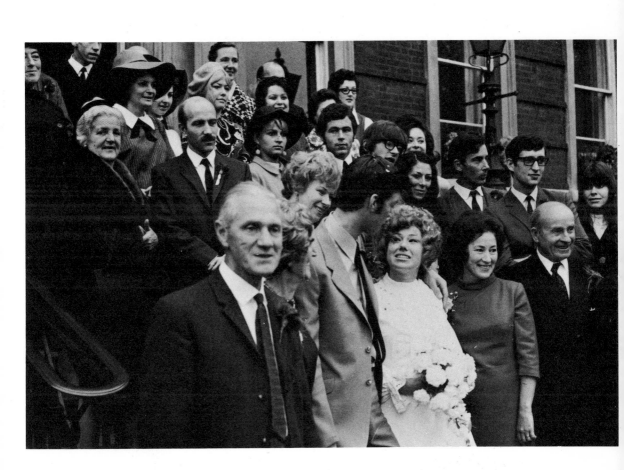

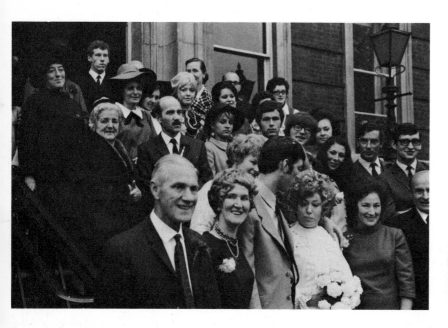

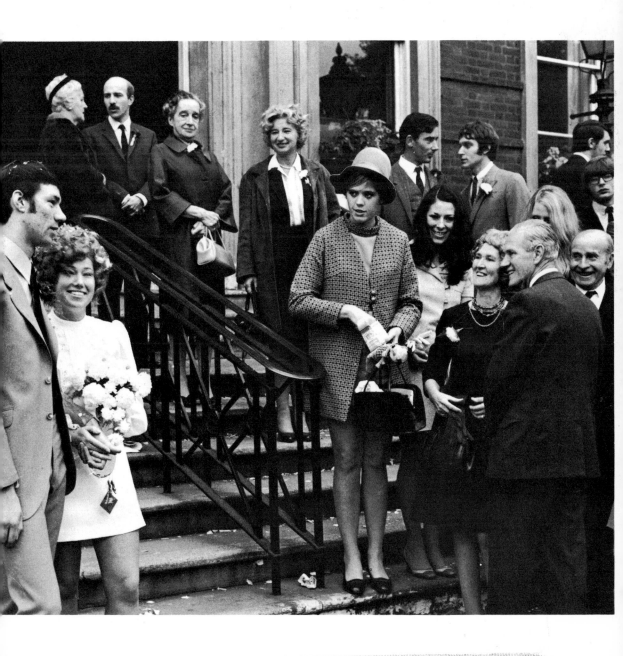

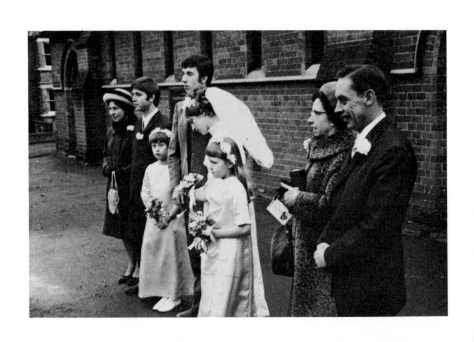

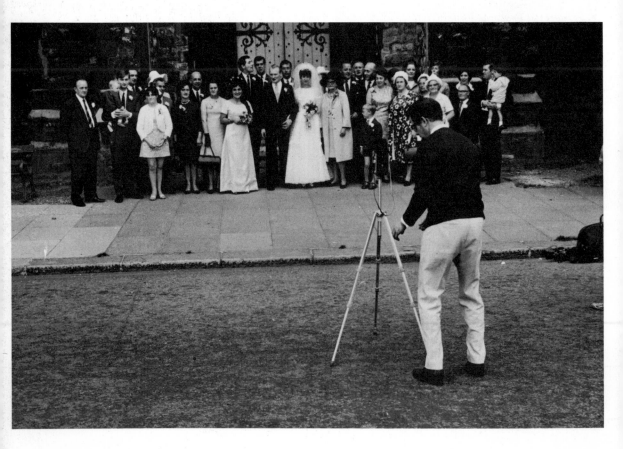

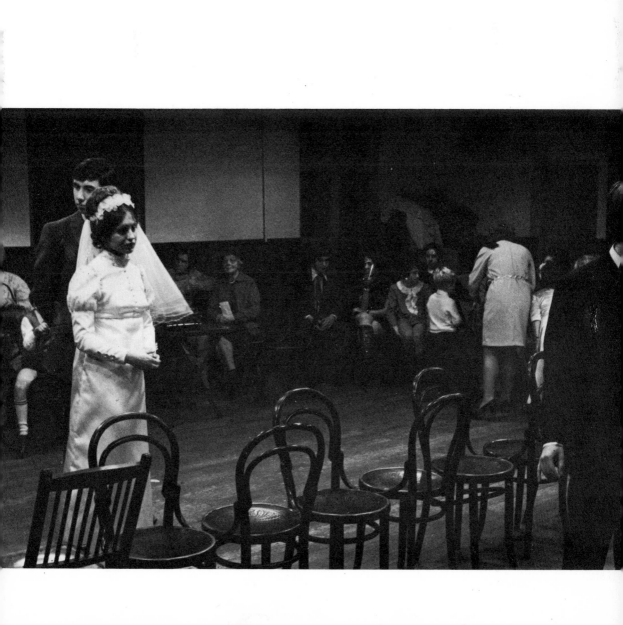

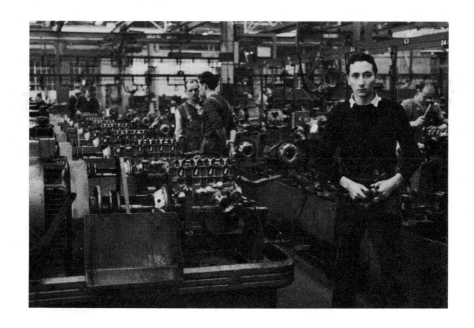

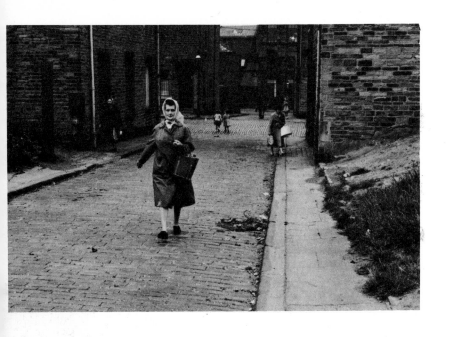

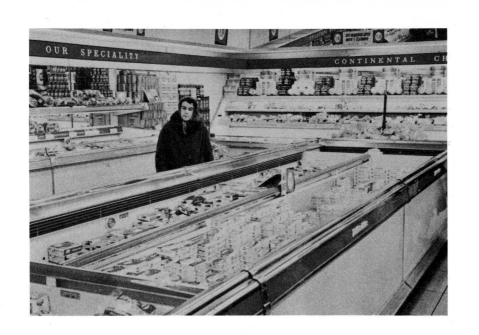

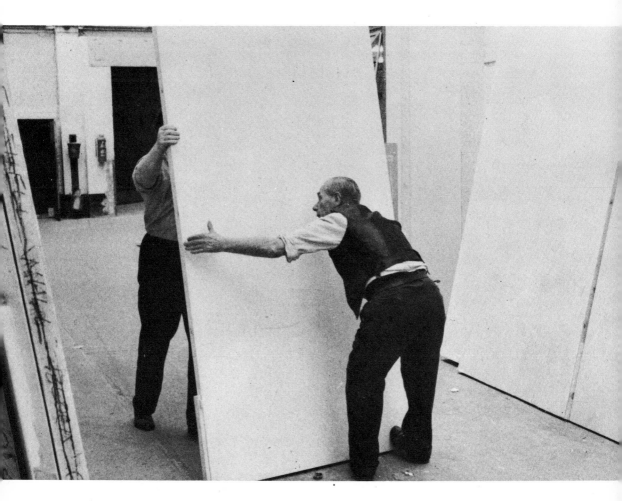

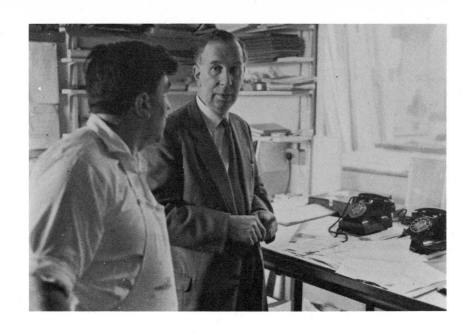

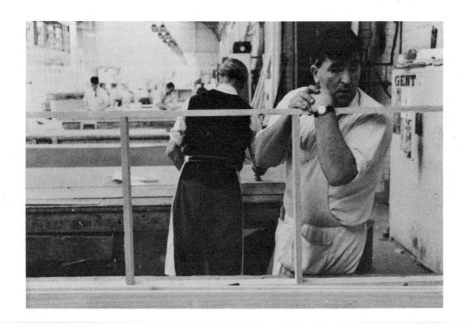

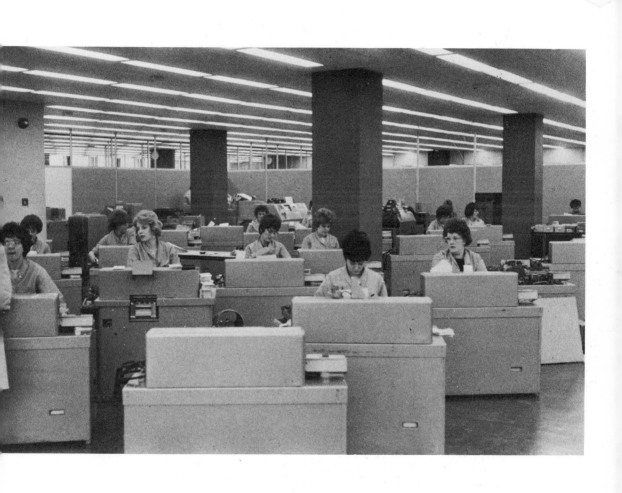

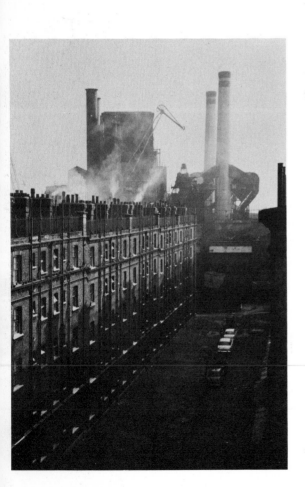

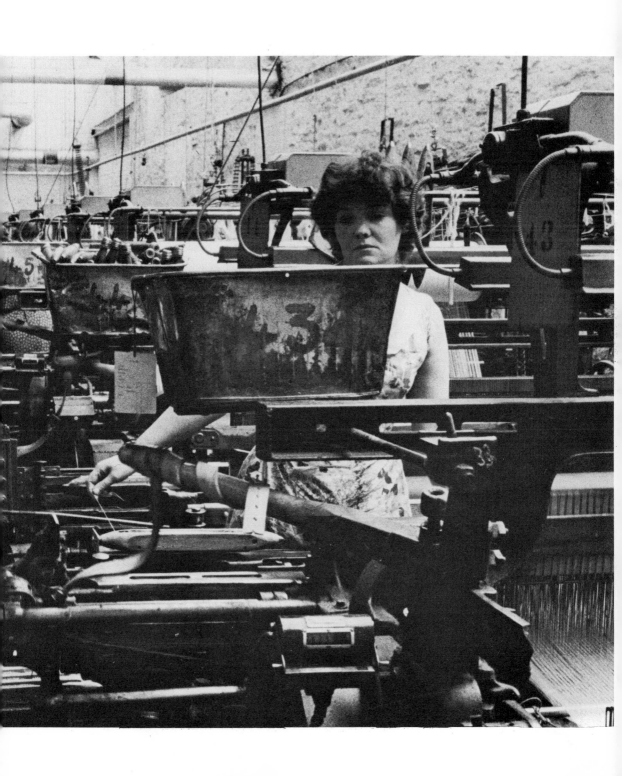

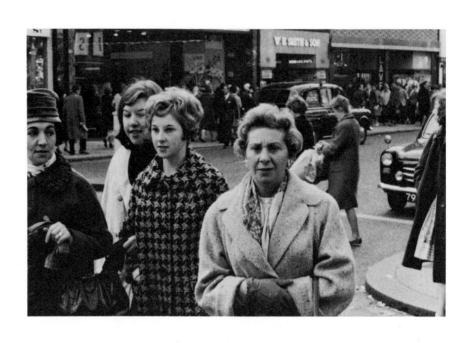

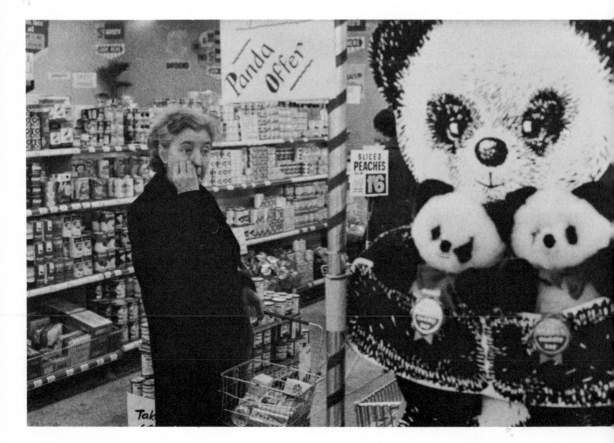

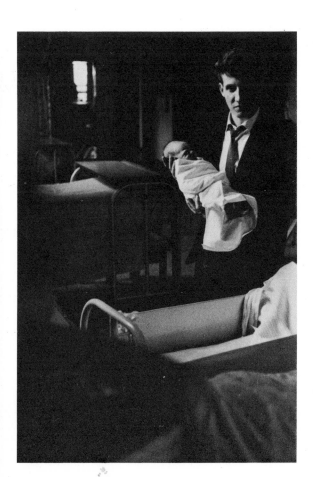

2

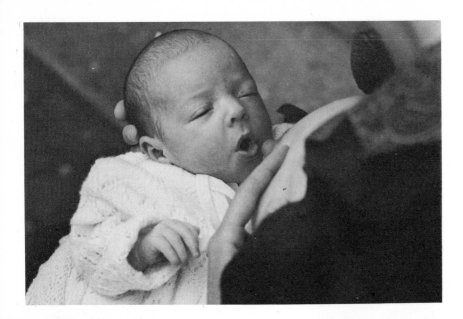

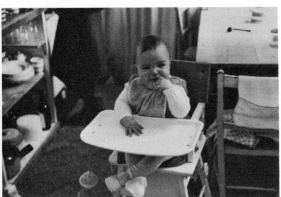
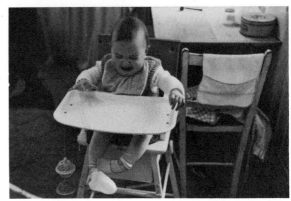

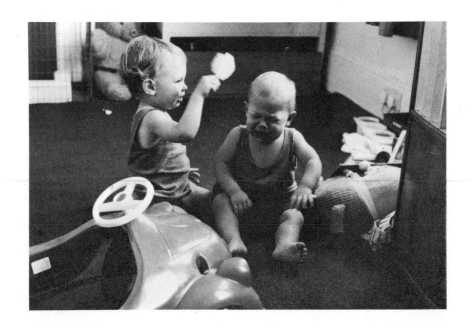

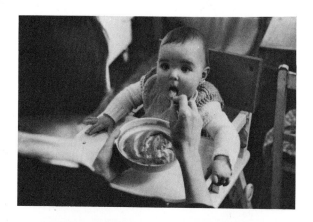

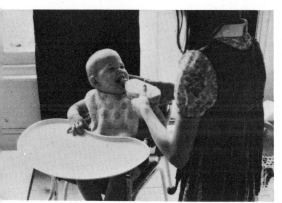

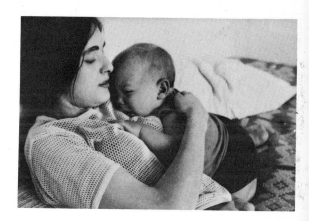

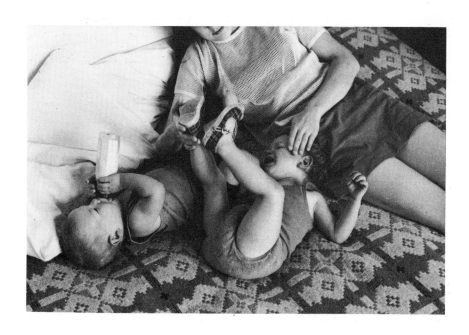

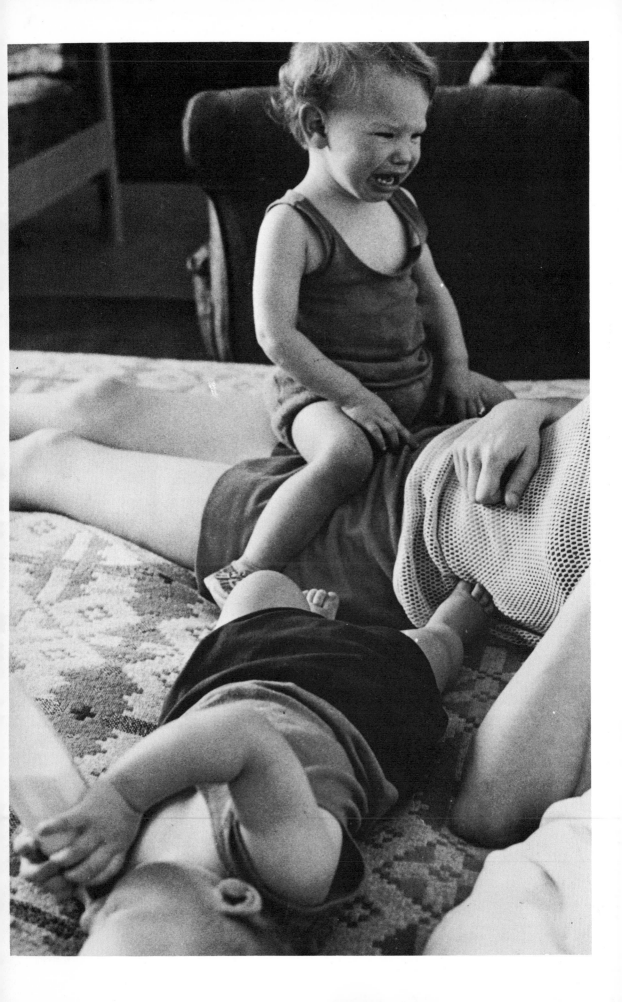

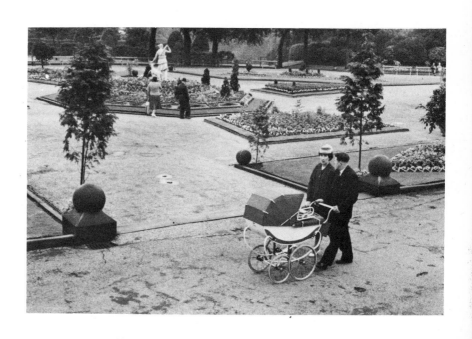

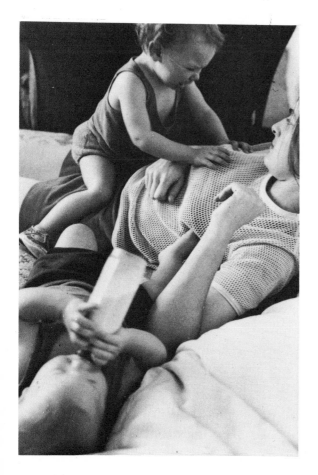

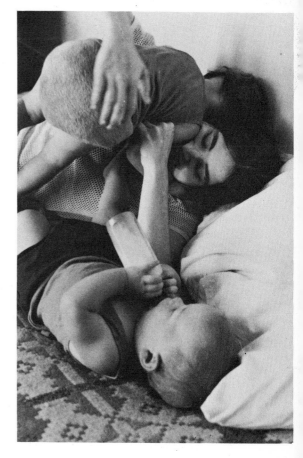

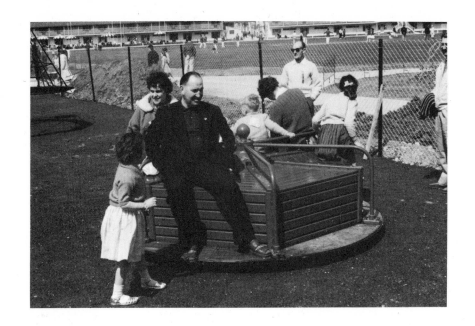

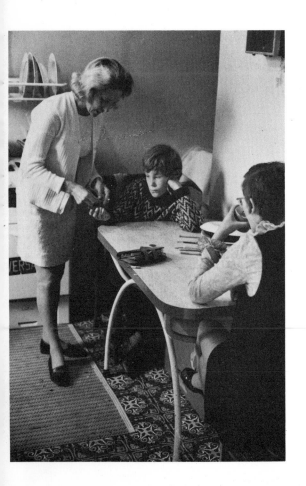

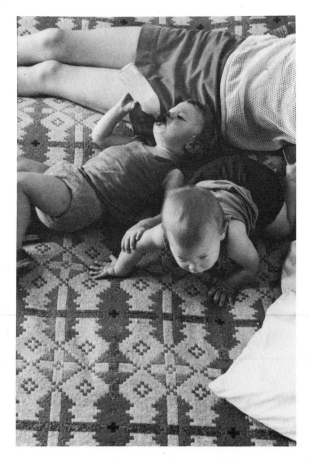

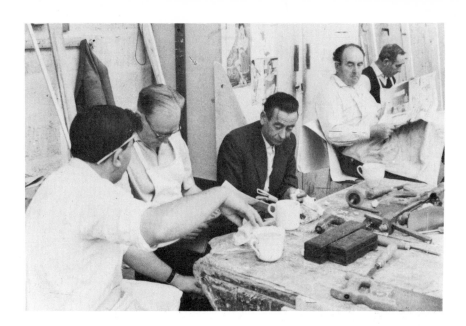

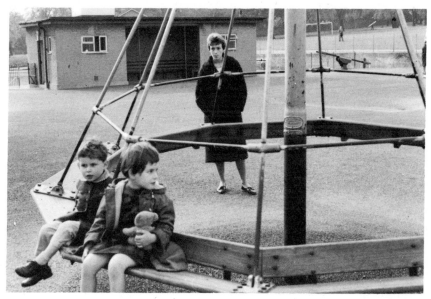

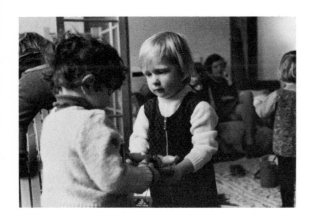

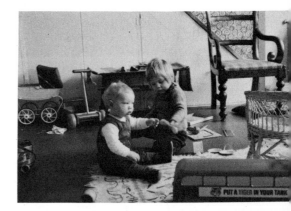

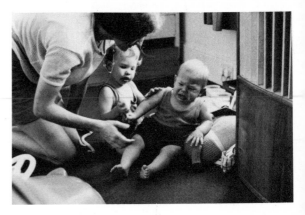

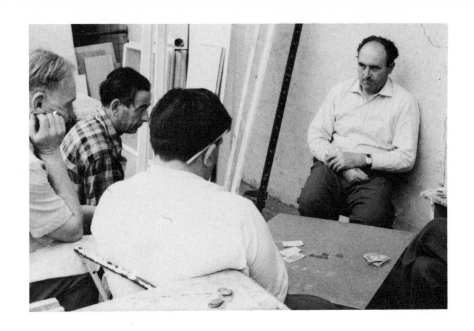

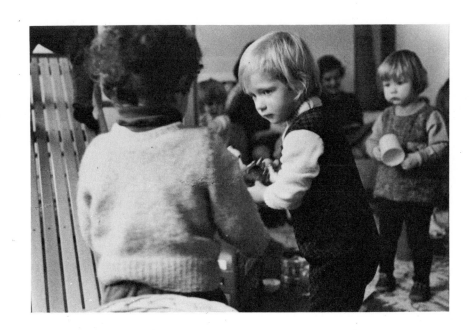

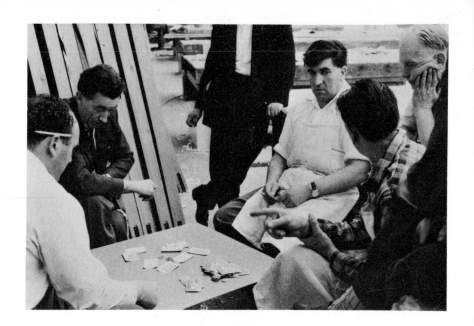

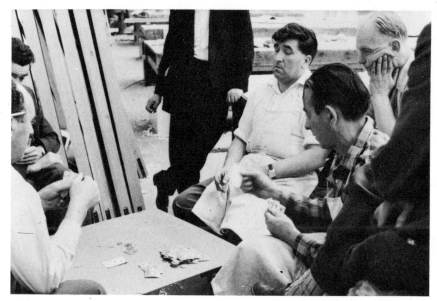

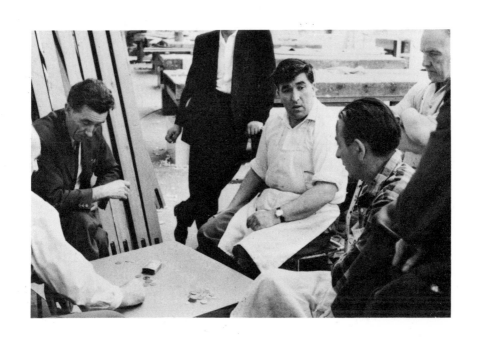

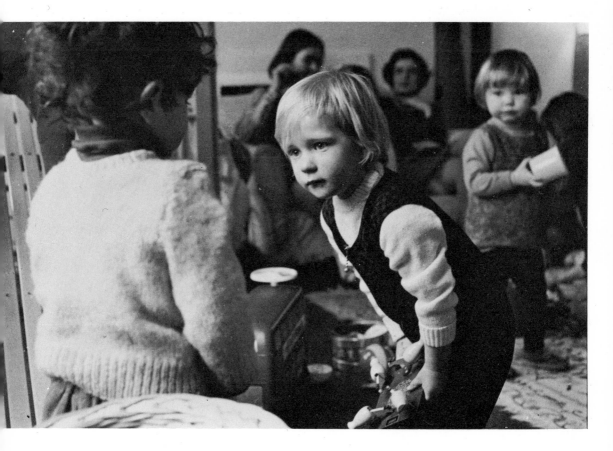

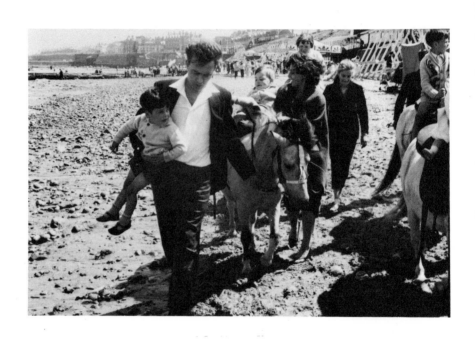

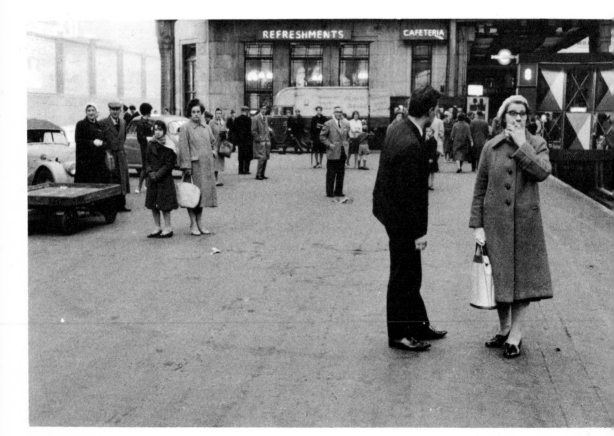

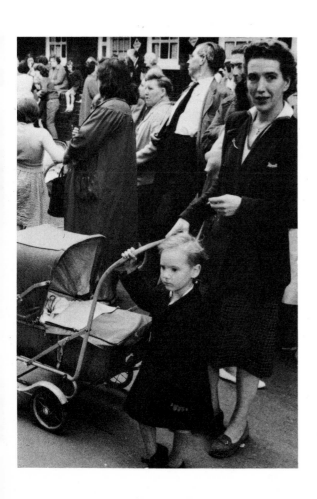

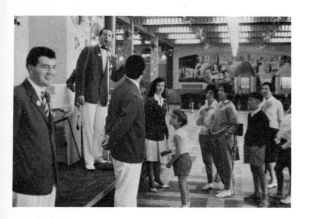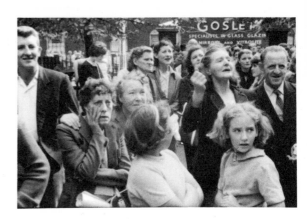

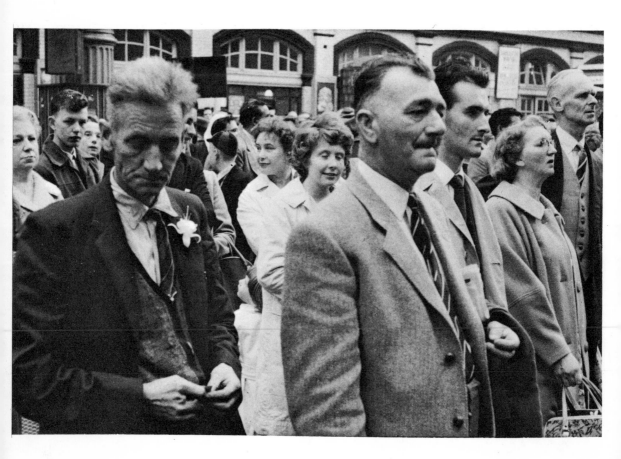

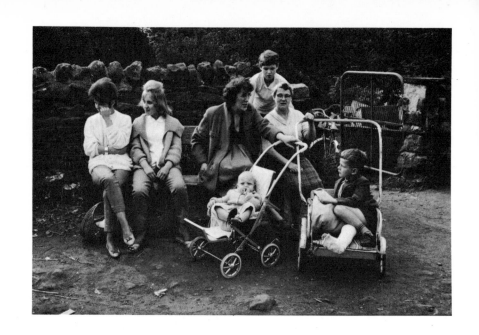

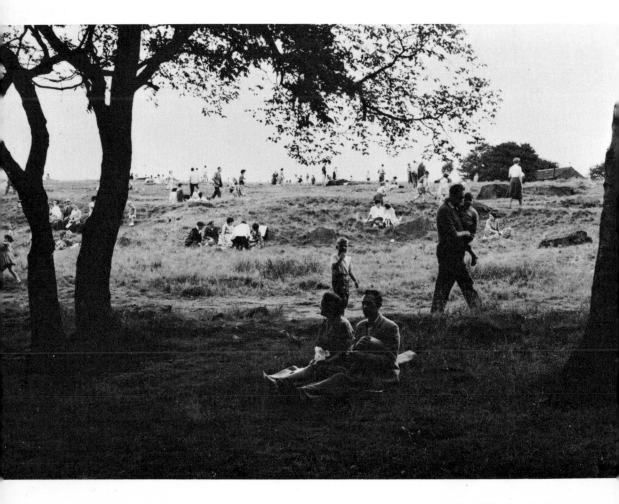

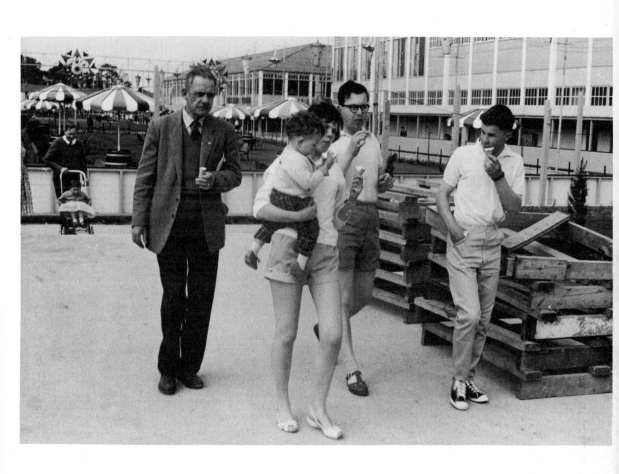

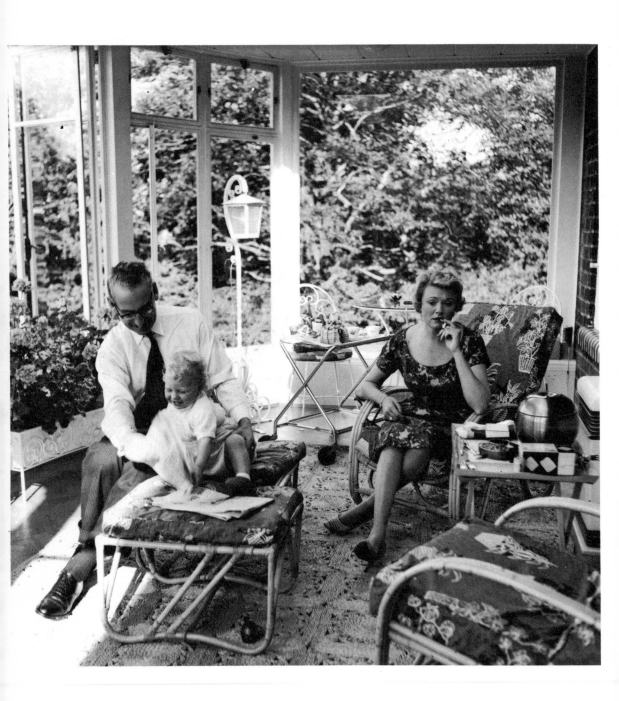

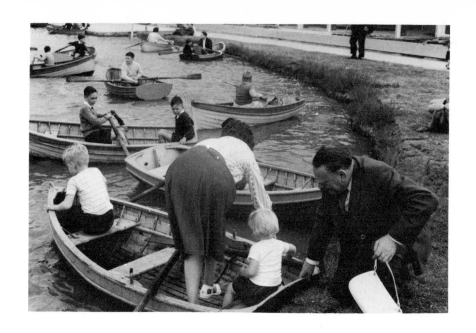

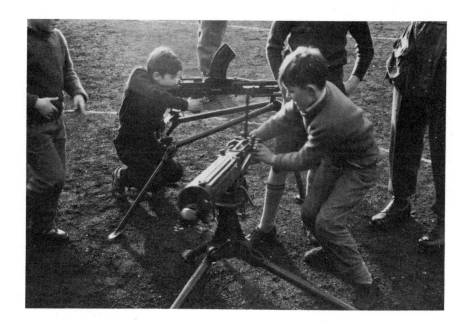

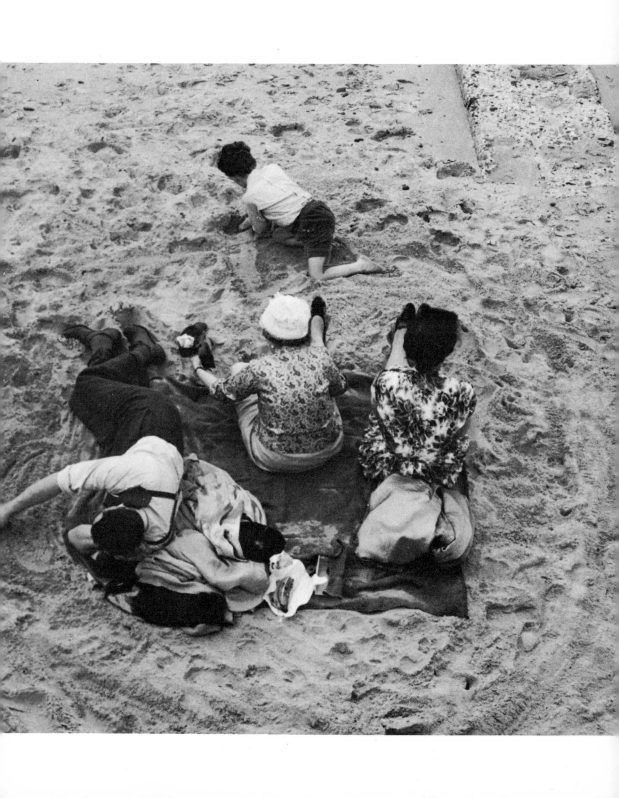

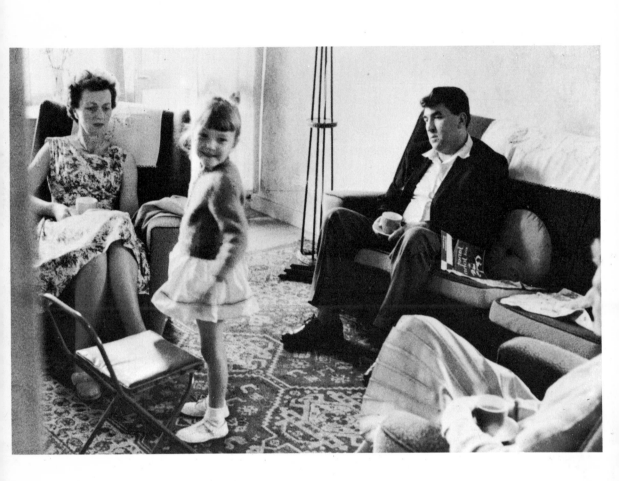

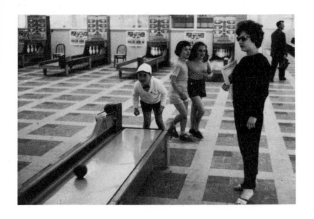

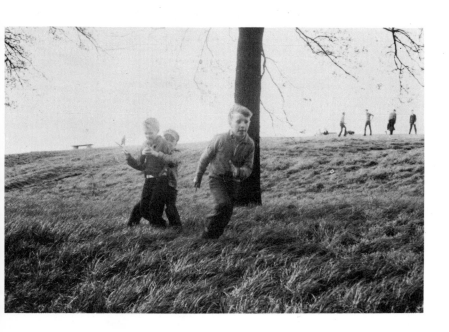

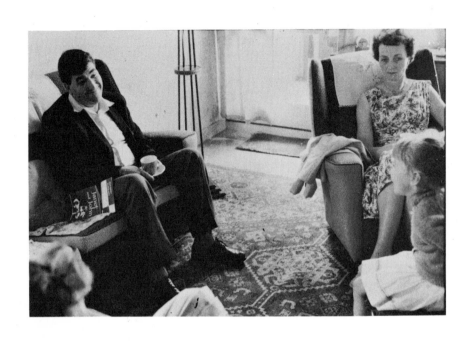

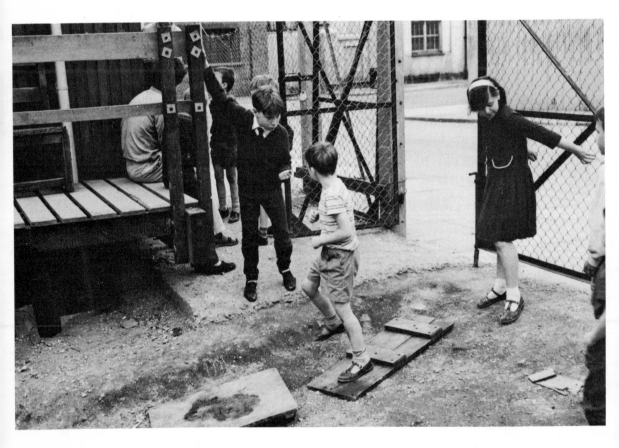

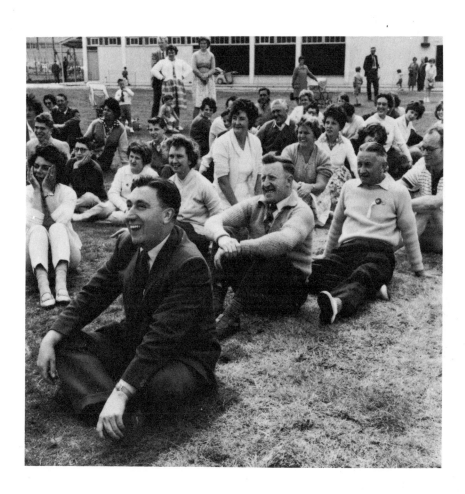

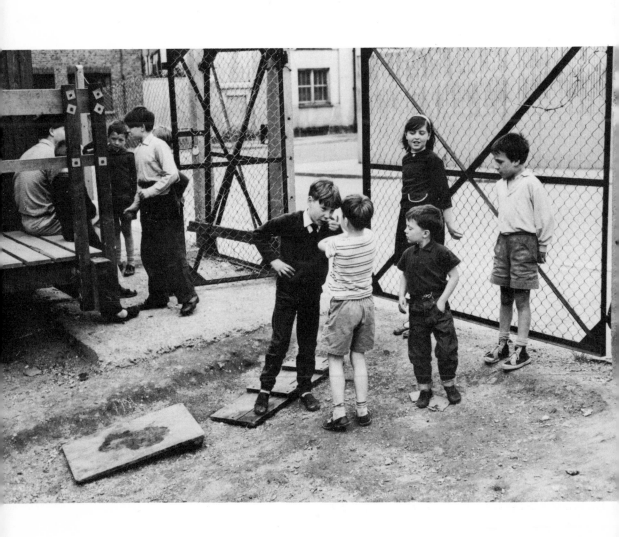

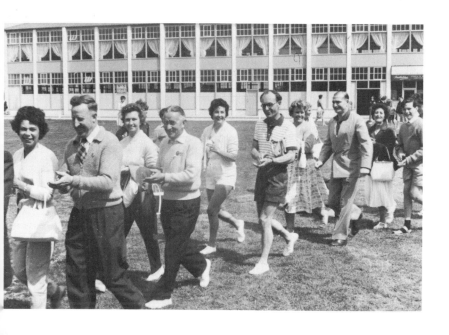

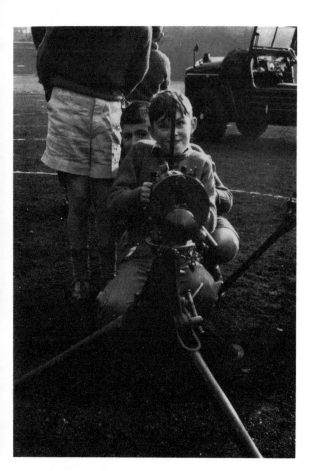

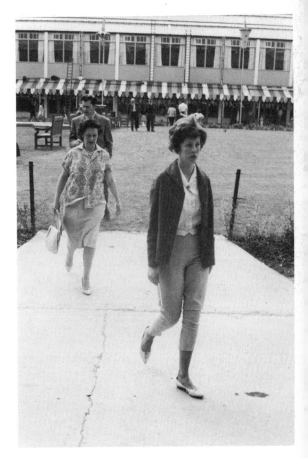

3

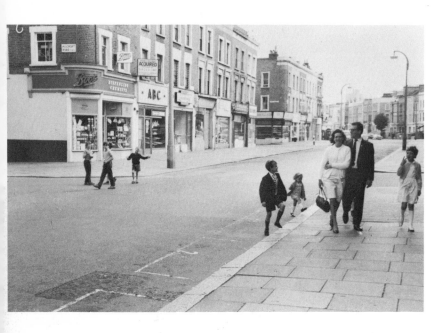

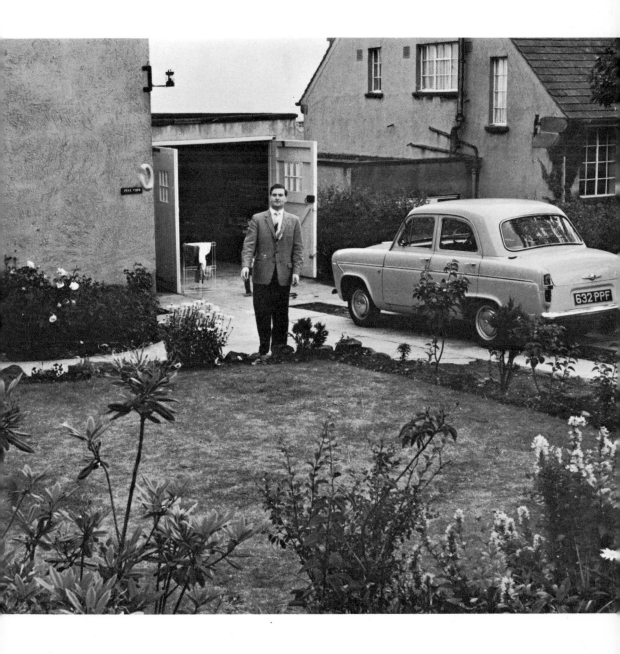

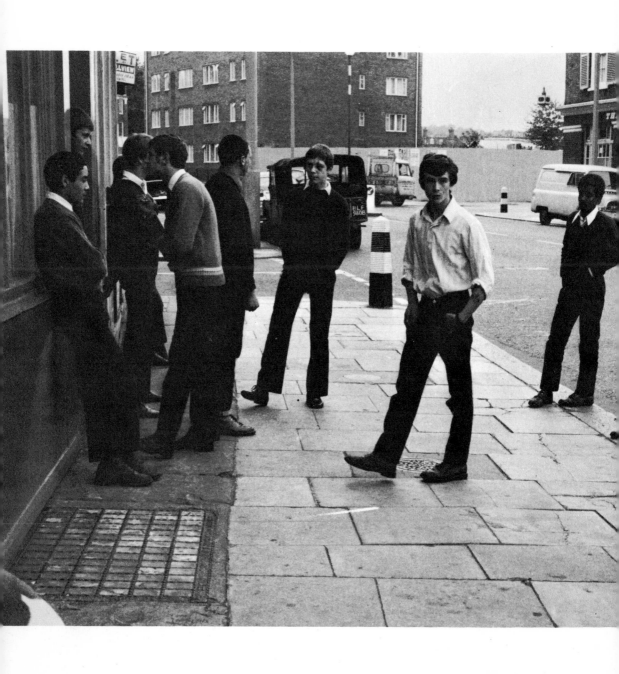

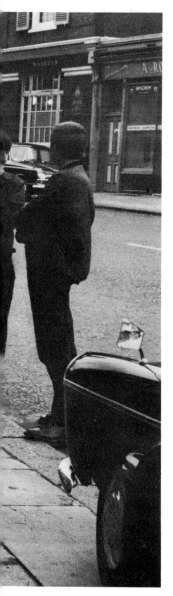

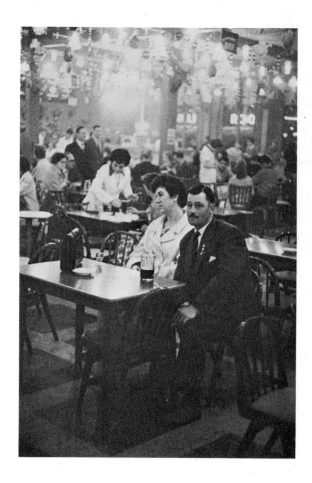

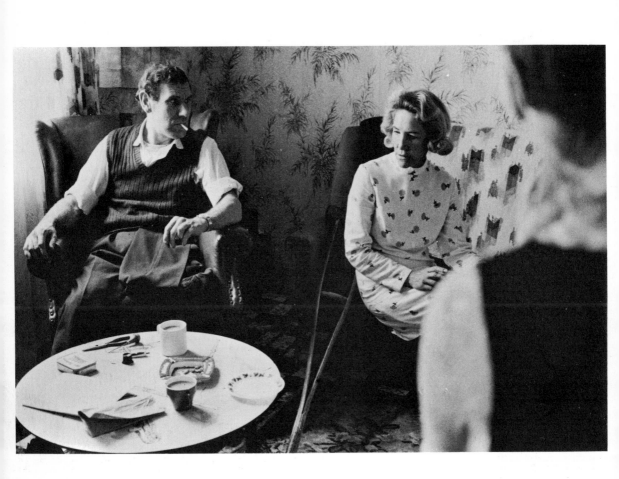

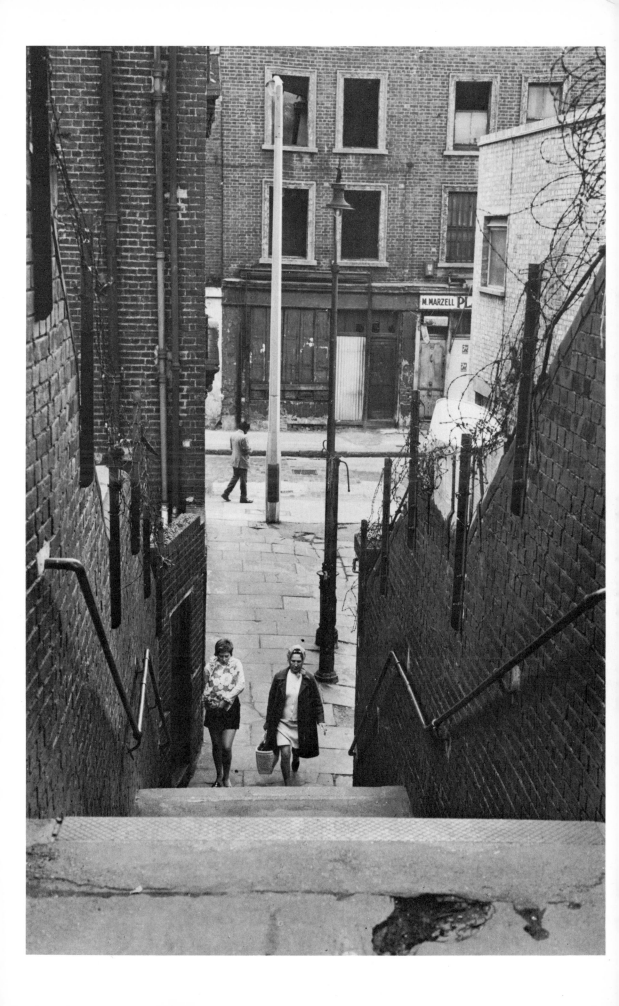

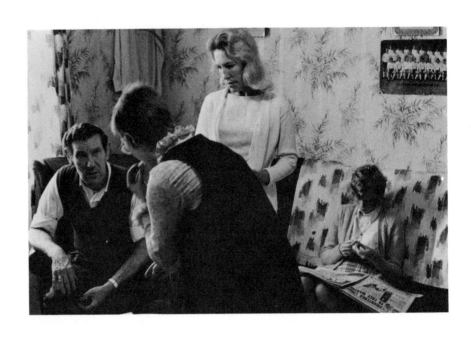

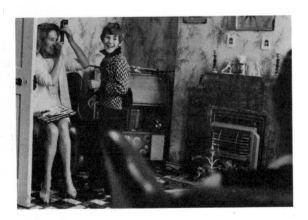

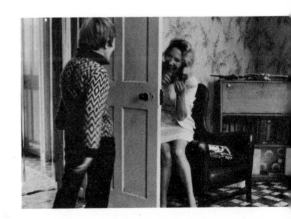

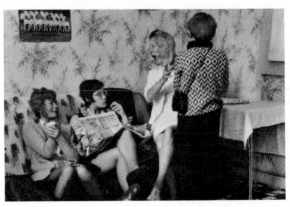

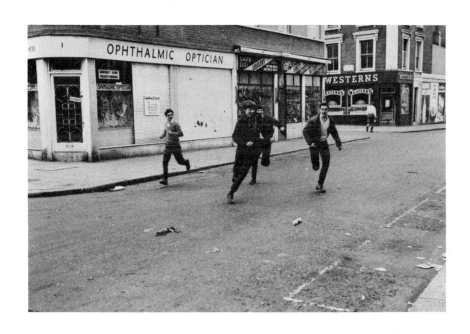

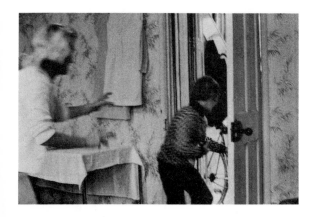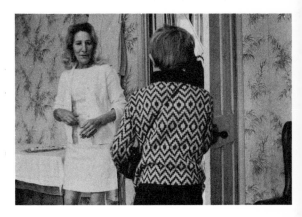

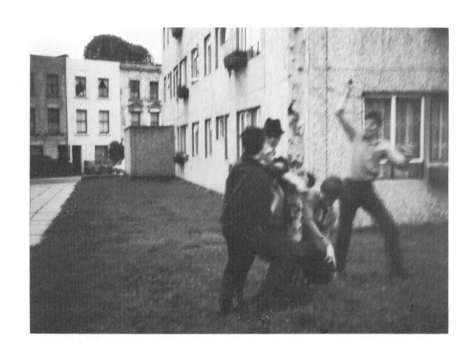

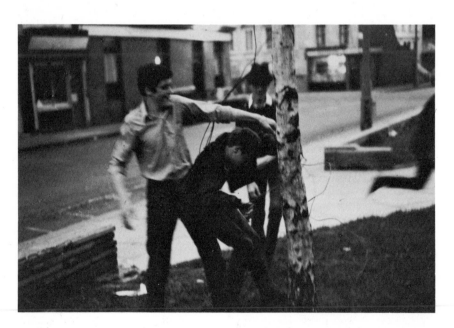

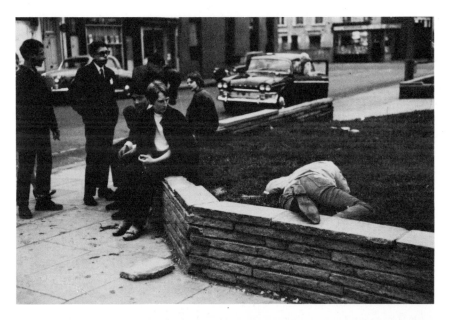

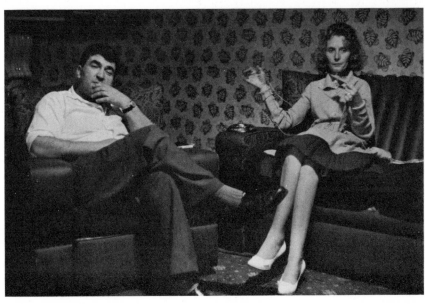

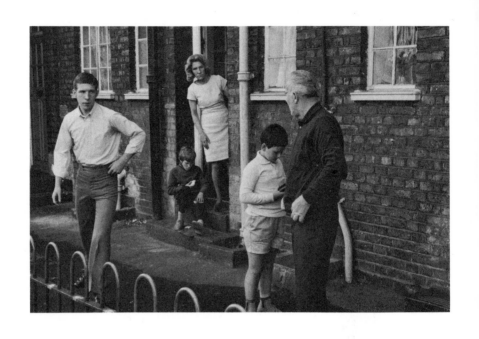

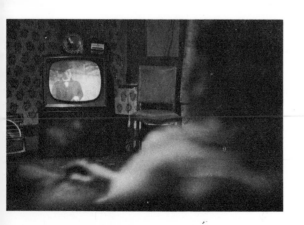
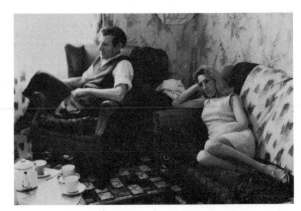

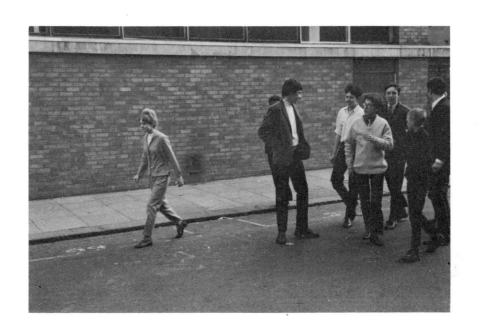

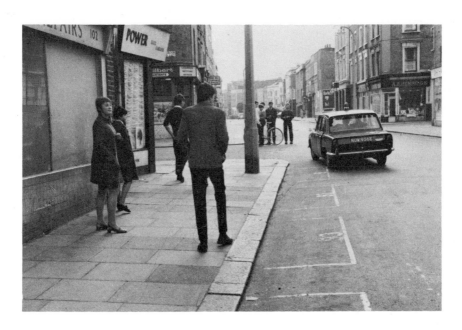

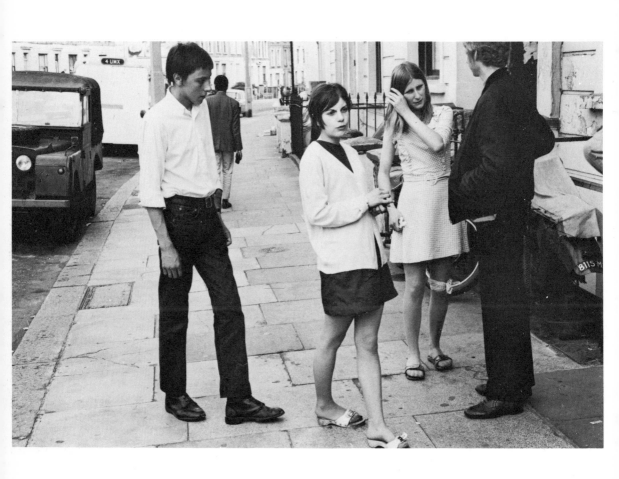

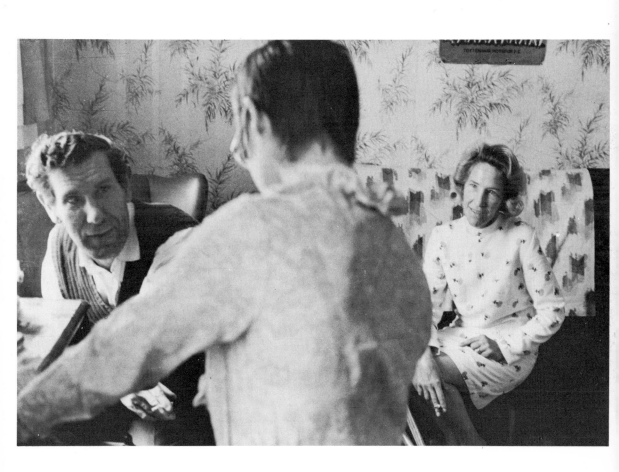

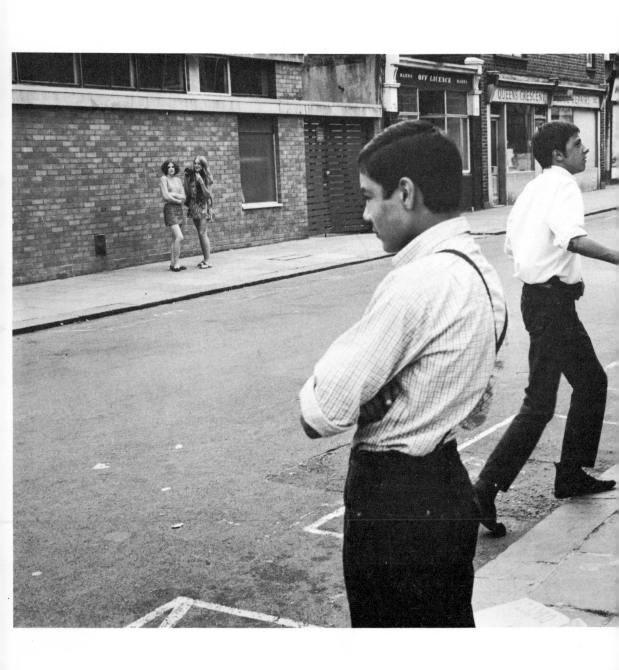

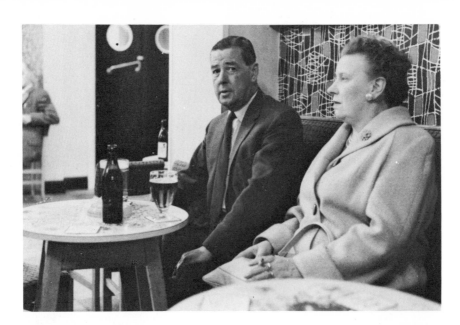

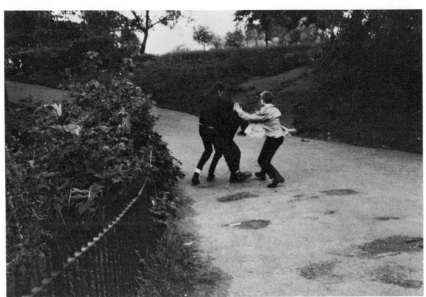

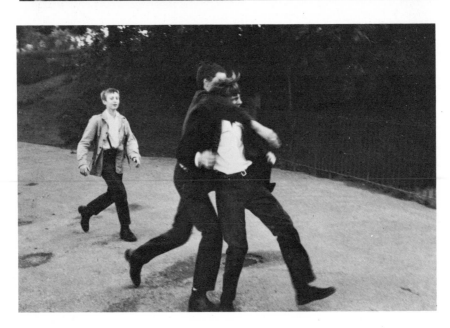

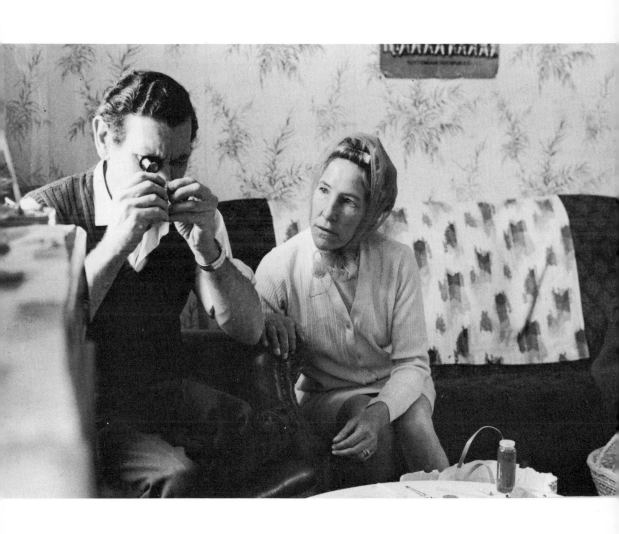

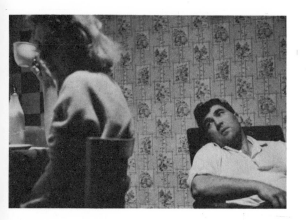
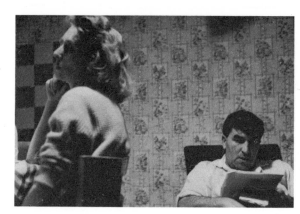
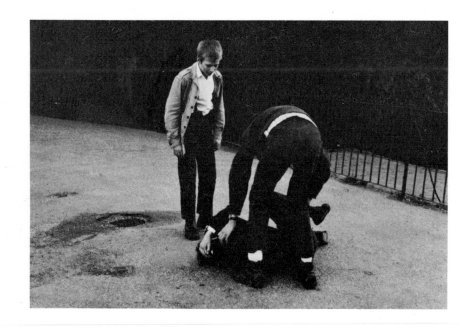

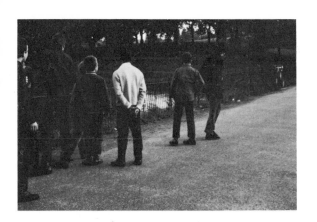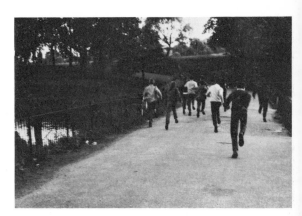

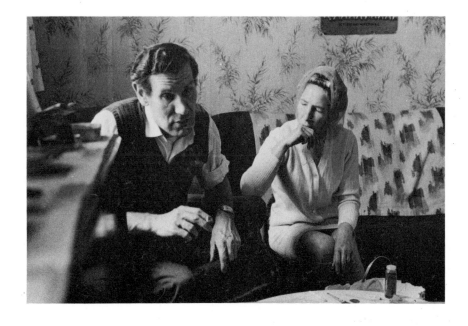

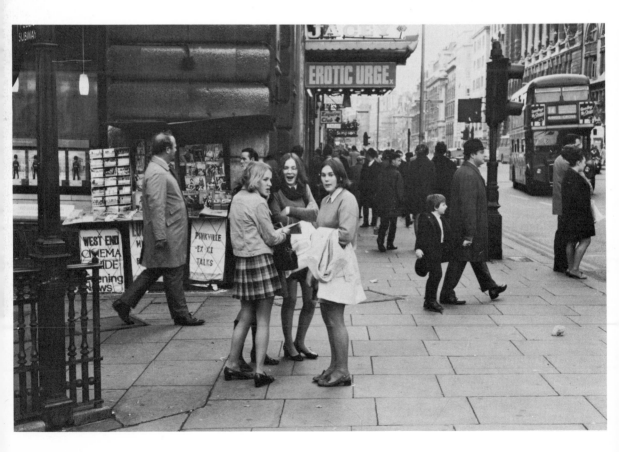

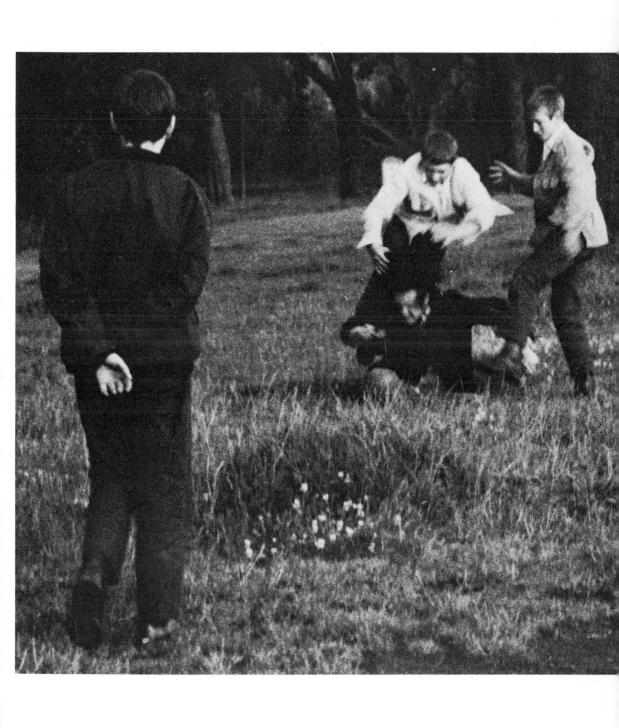

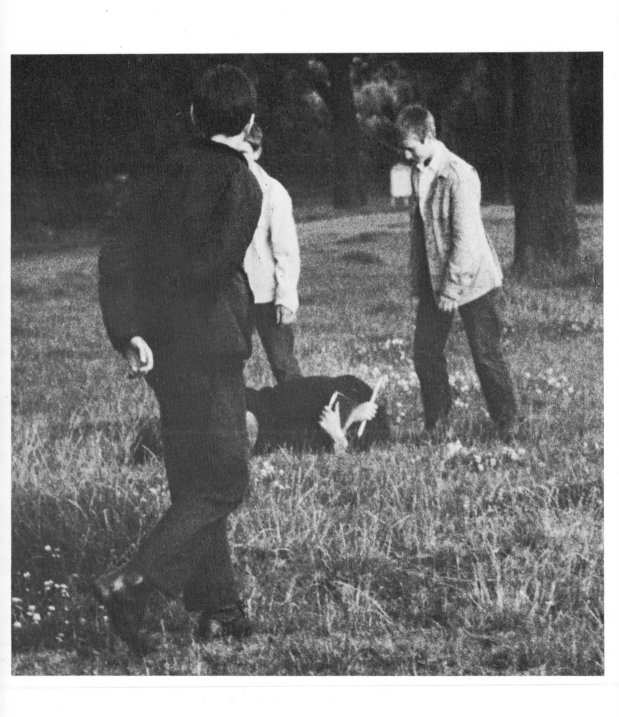

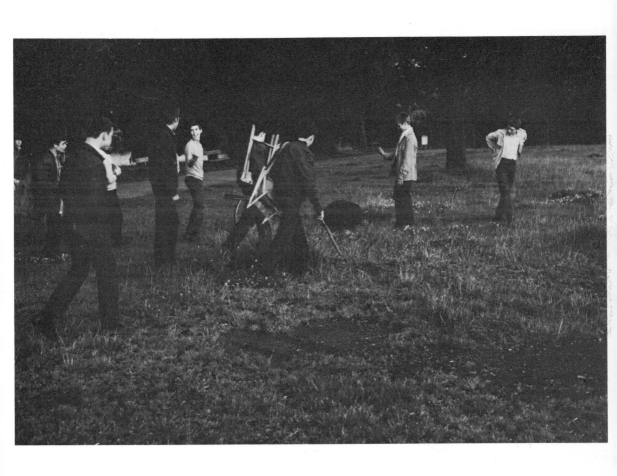

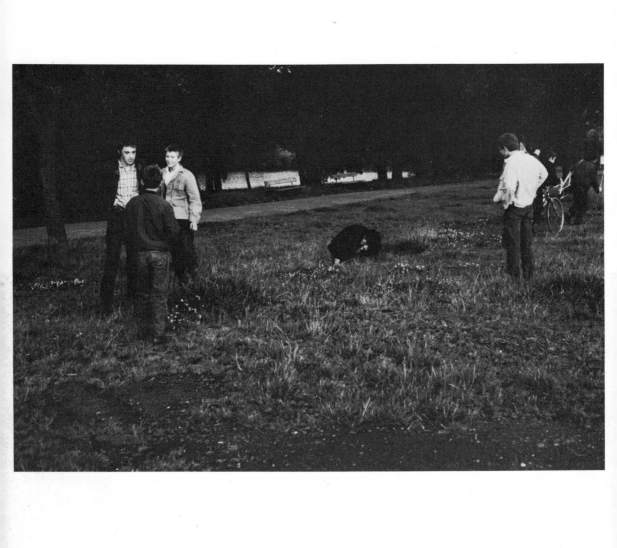

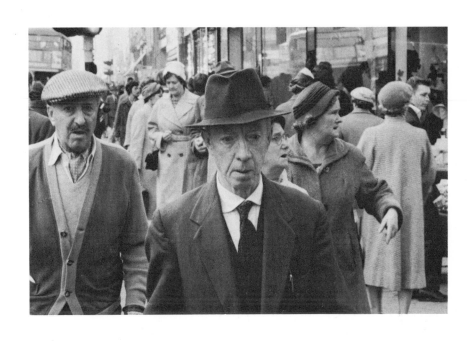

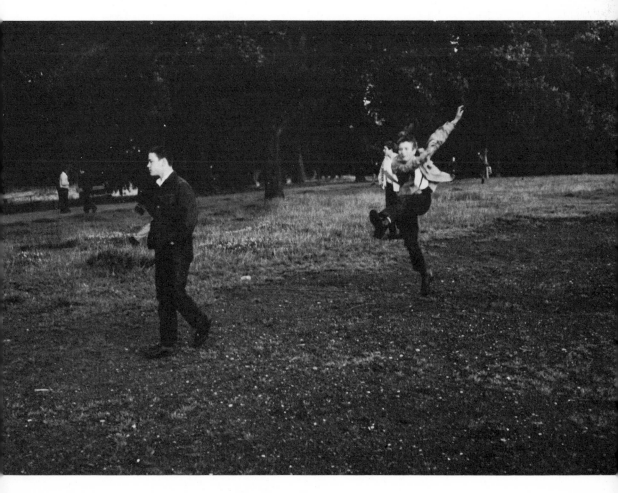

4

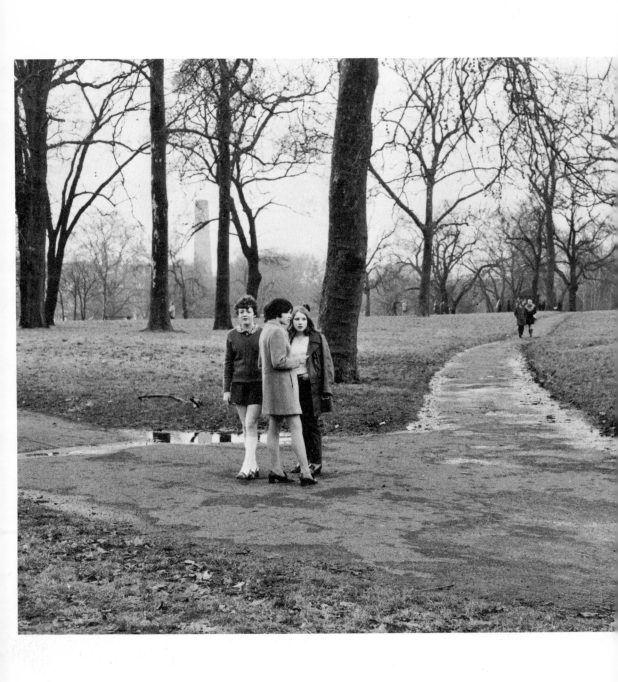

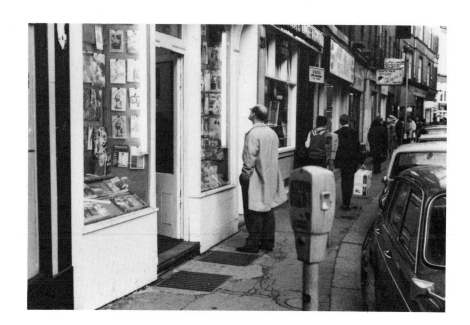

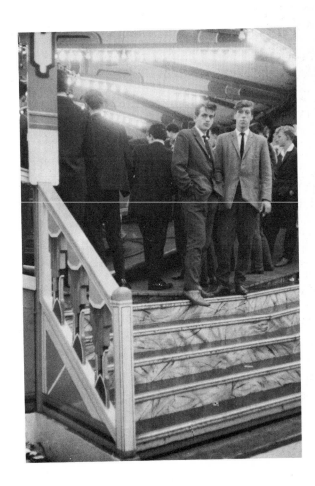

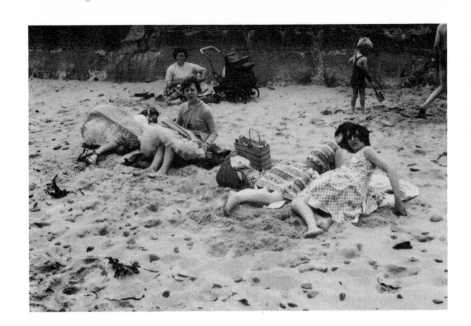

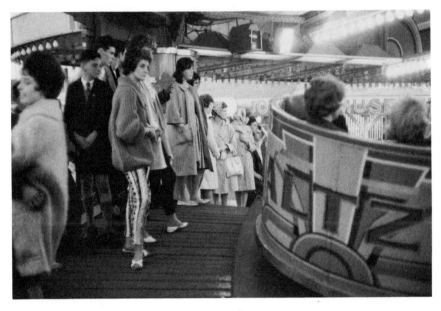

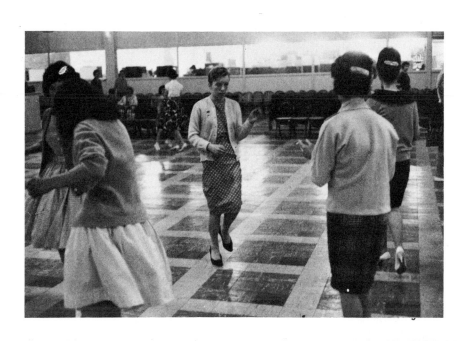

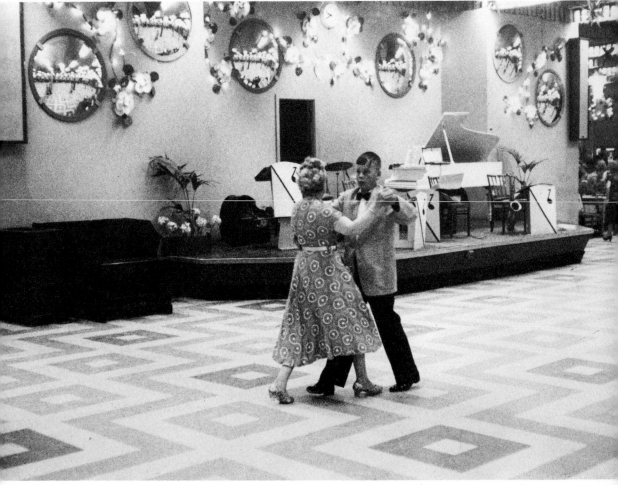

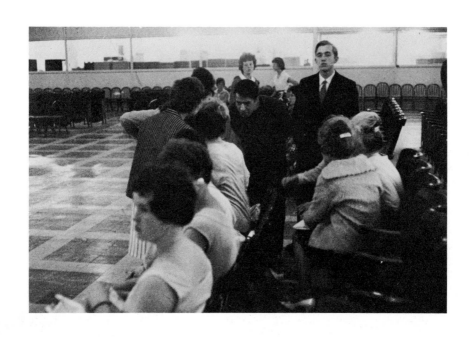

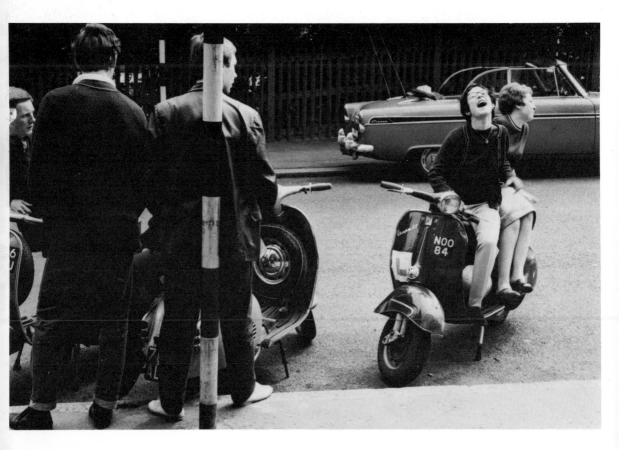

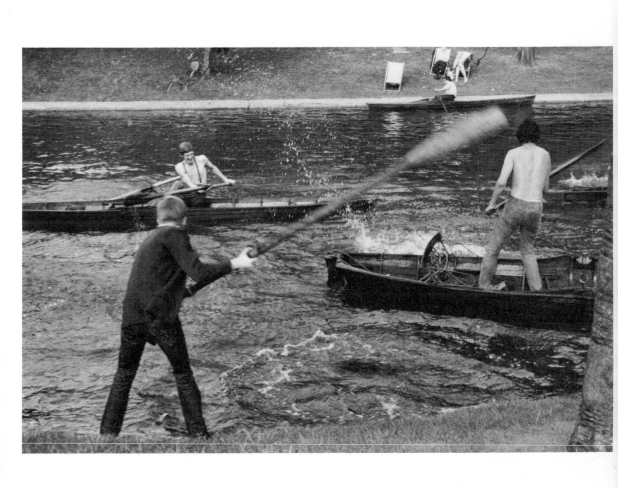

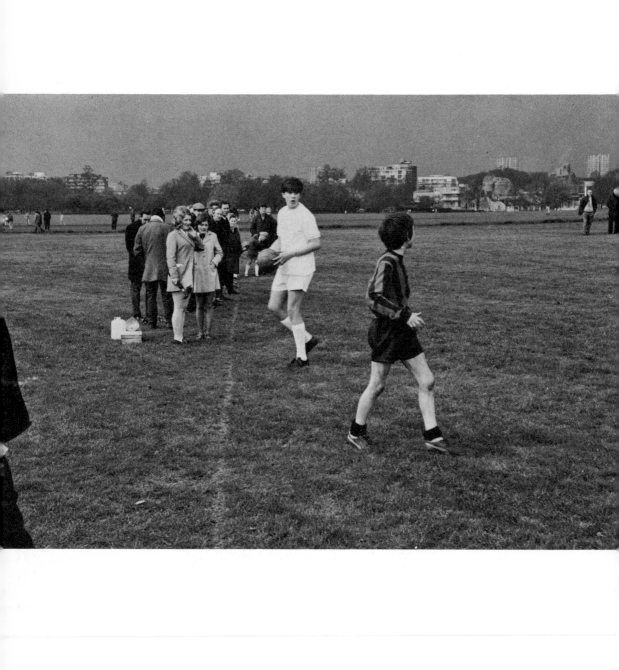

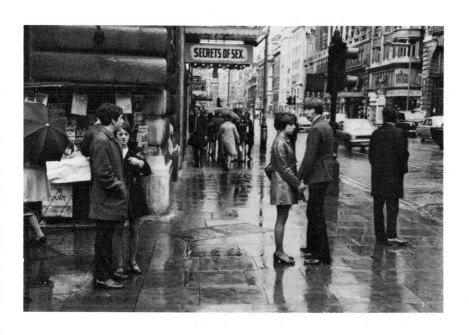

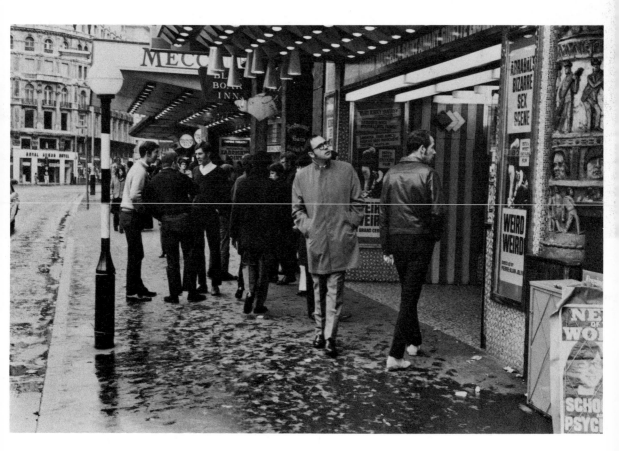

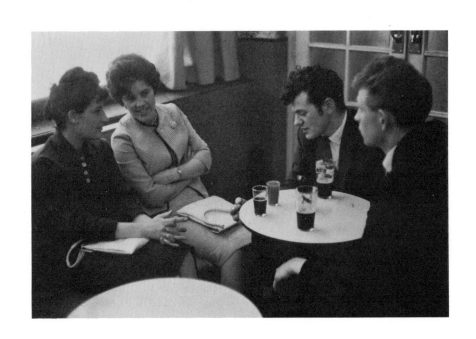

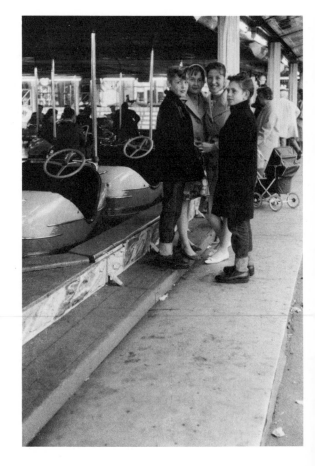

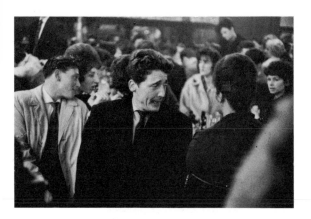

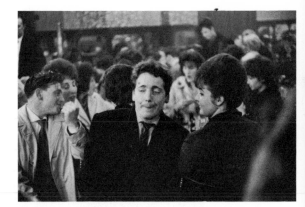

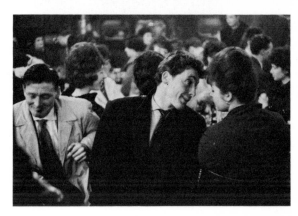

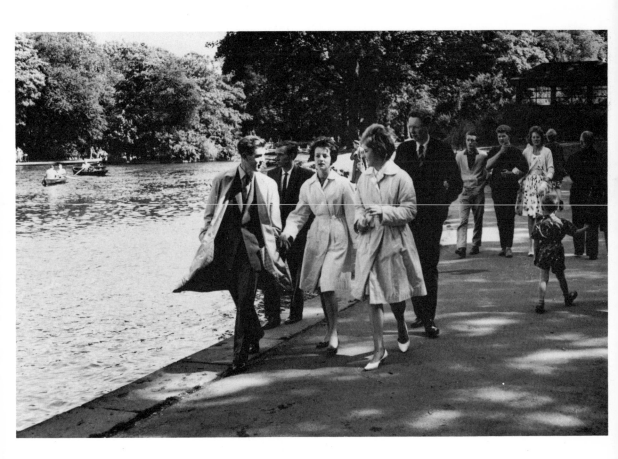

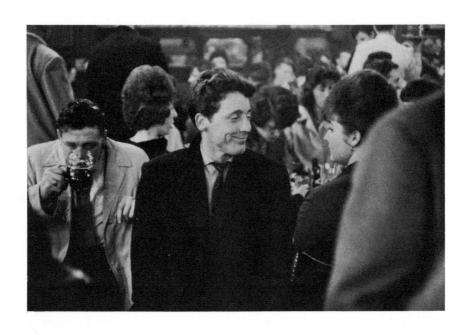

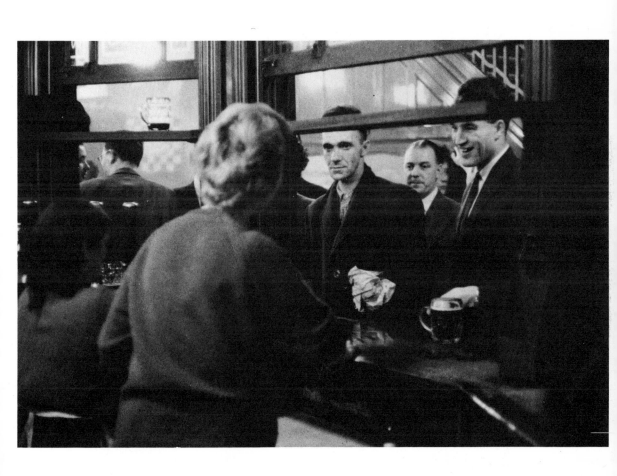

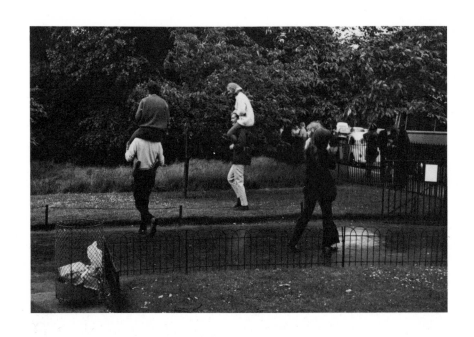

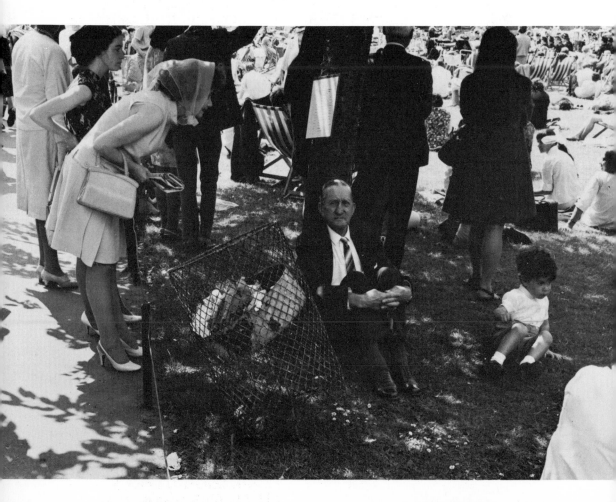

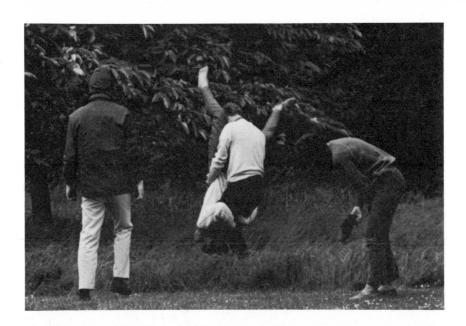

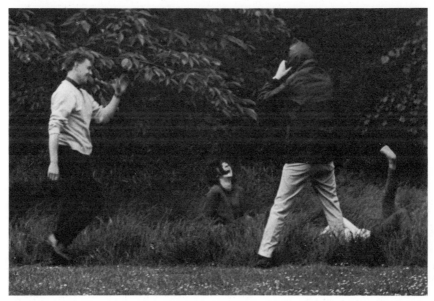

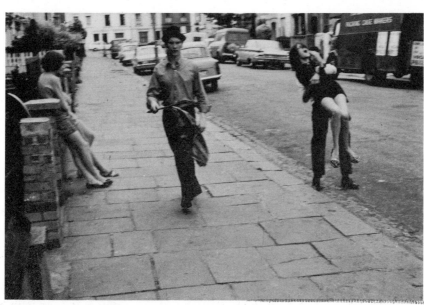

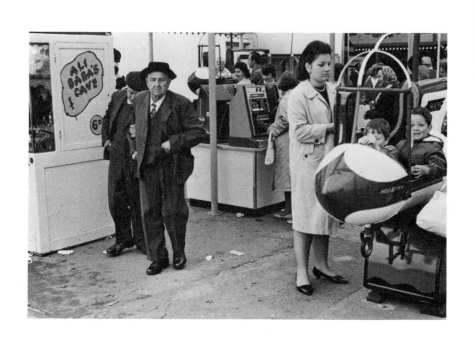

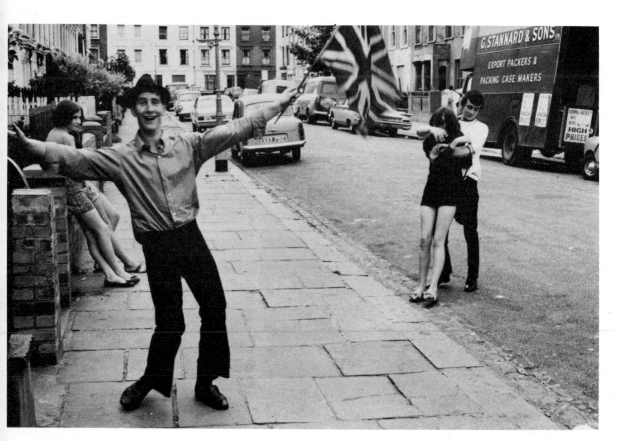

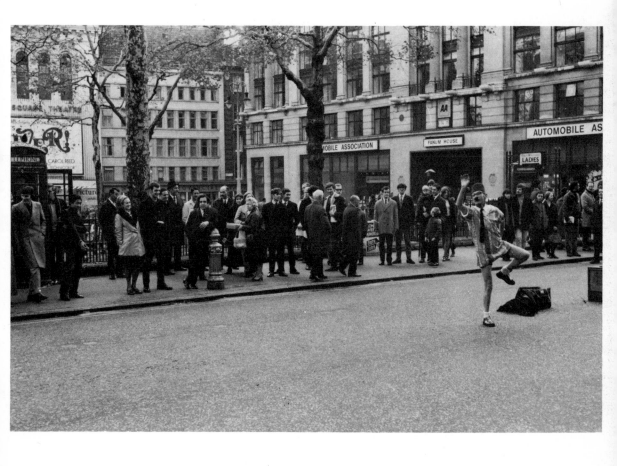

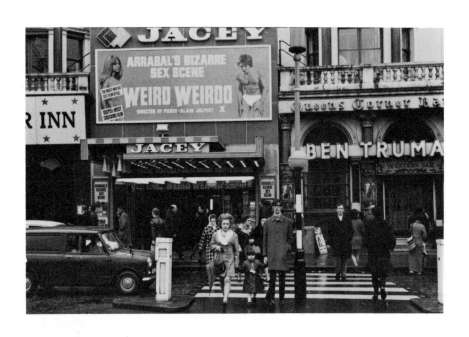

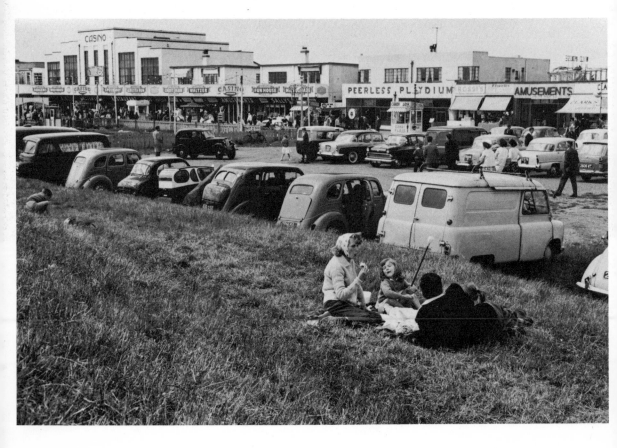

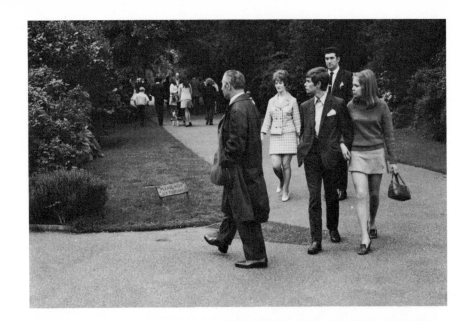

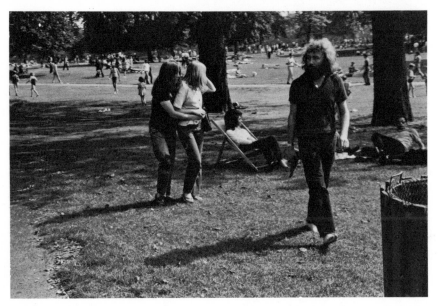

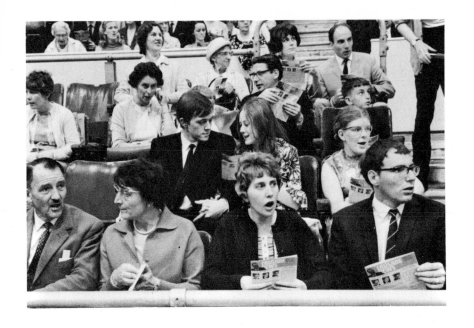

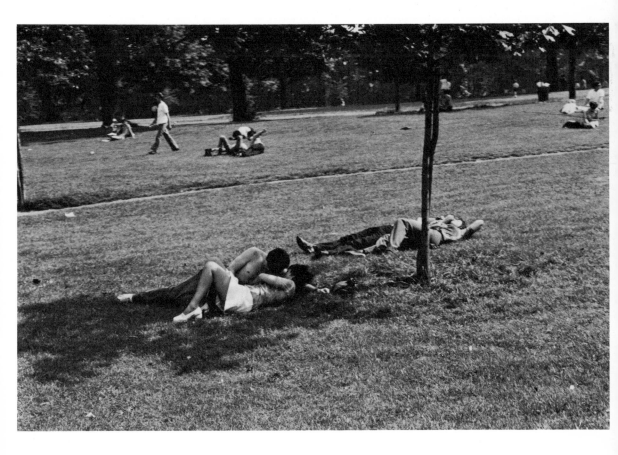

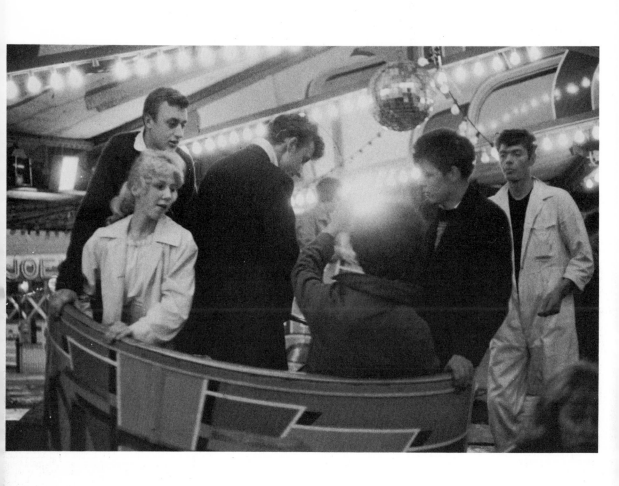

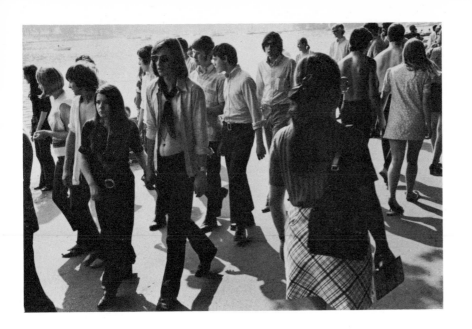

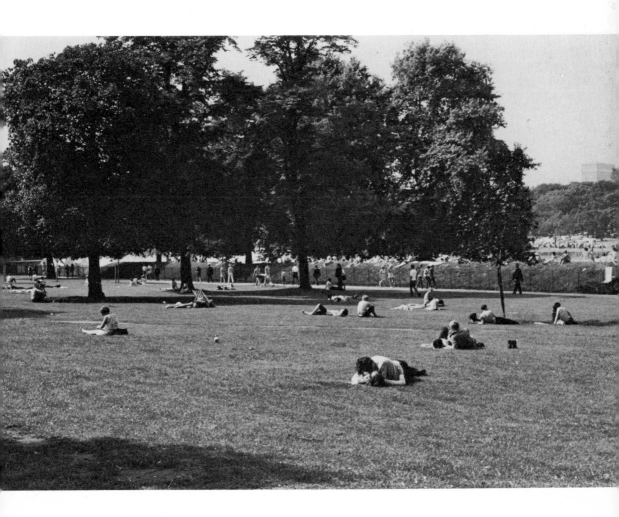

5

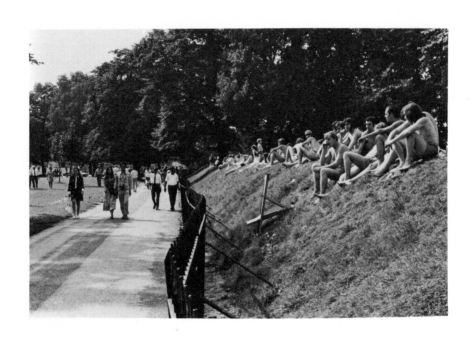

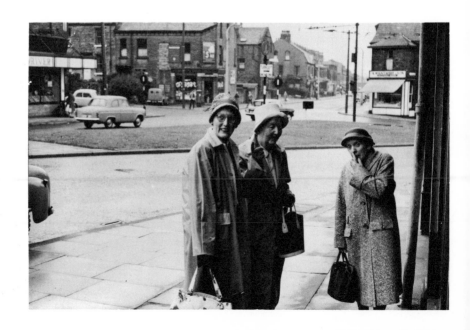

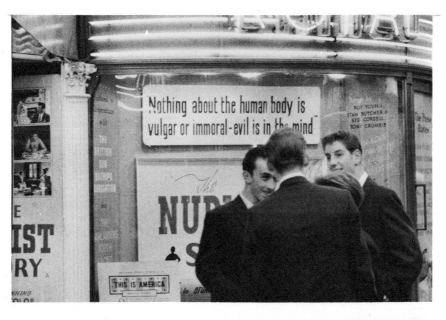

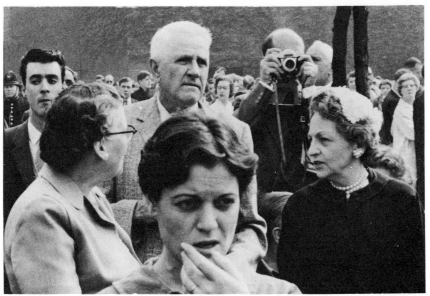

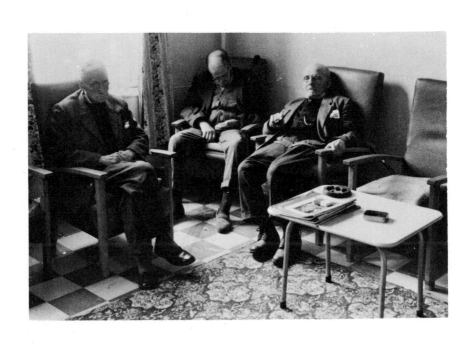

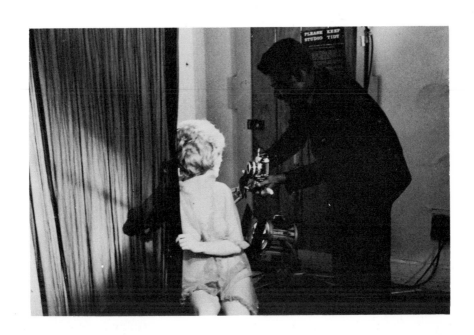

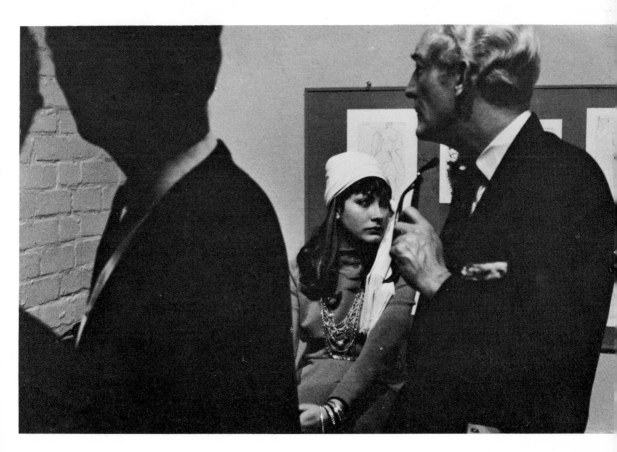

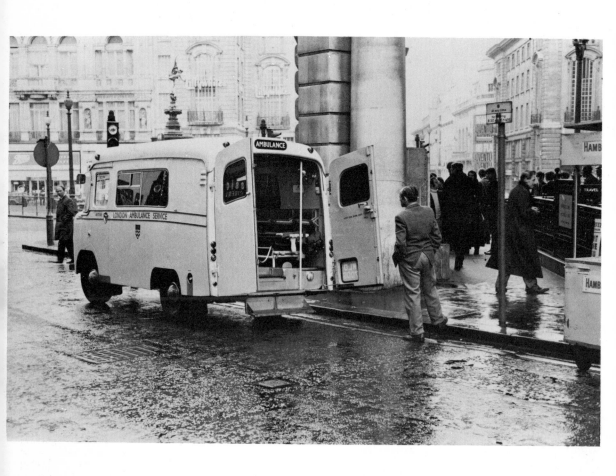

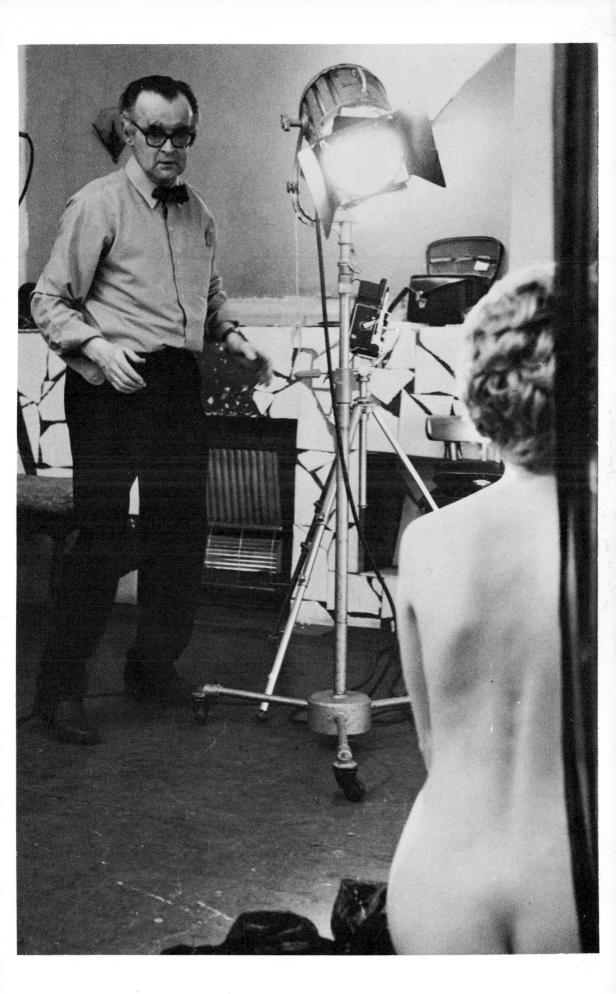

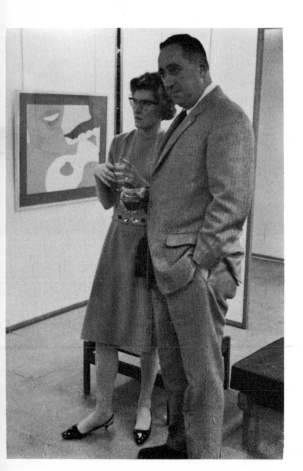

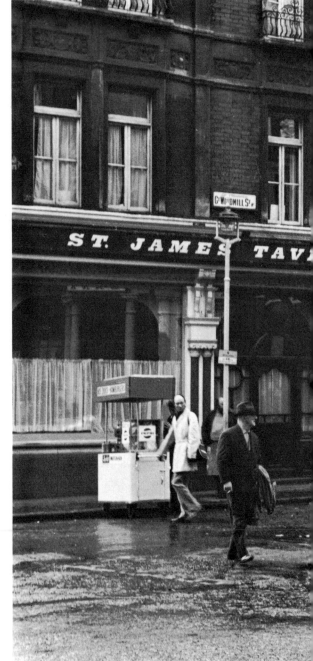

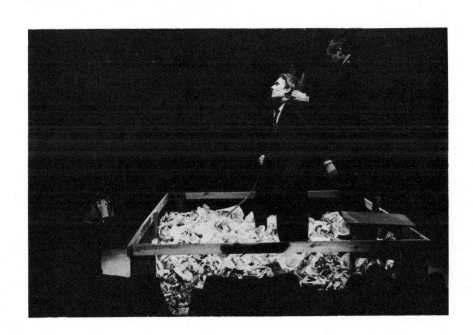

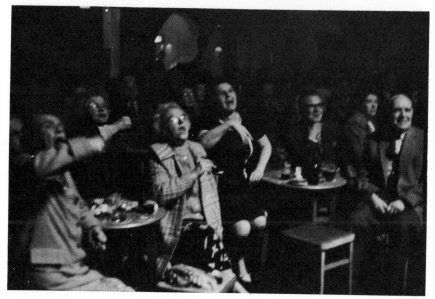

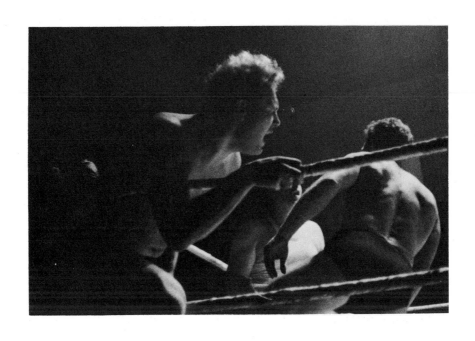

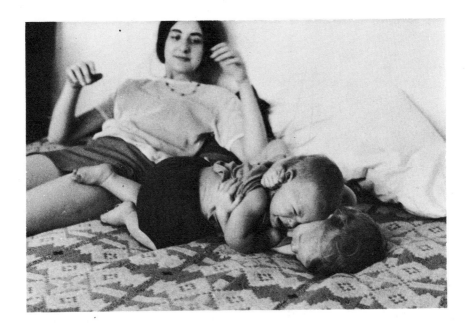

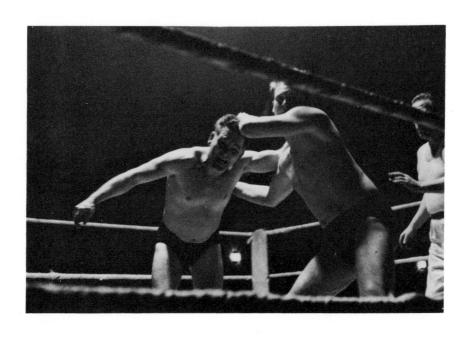

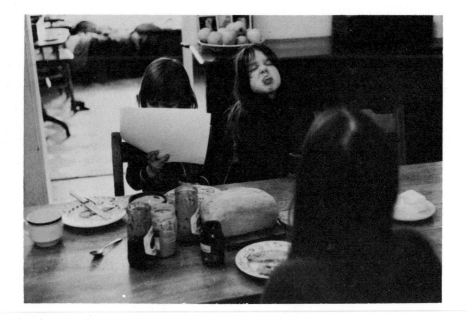

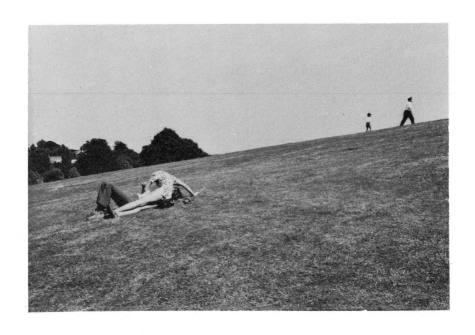

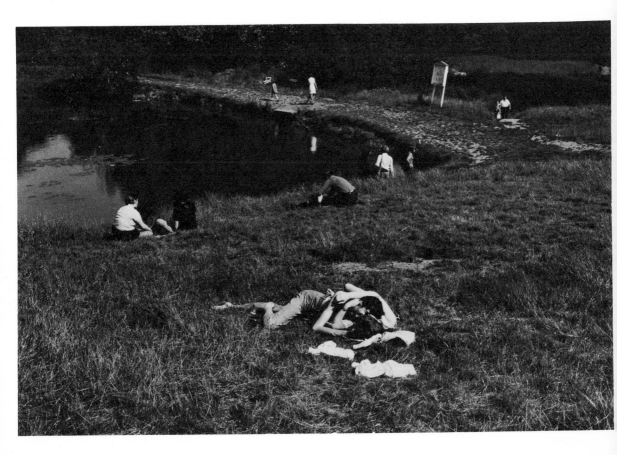

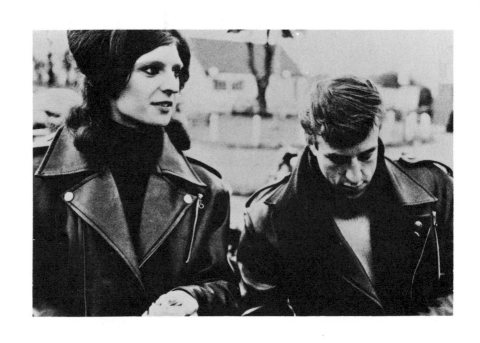

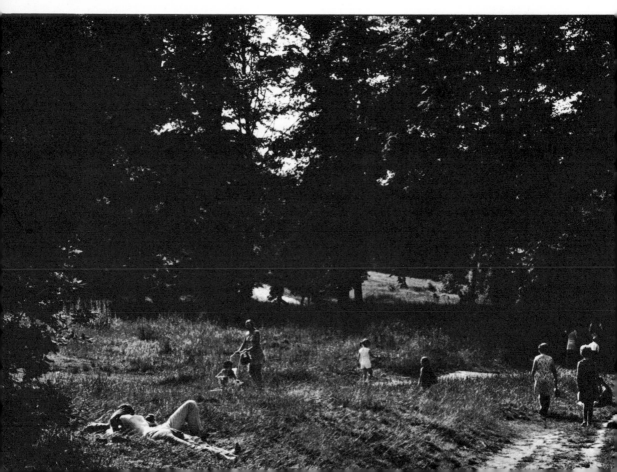

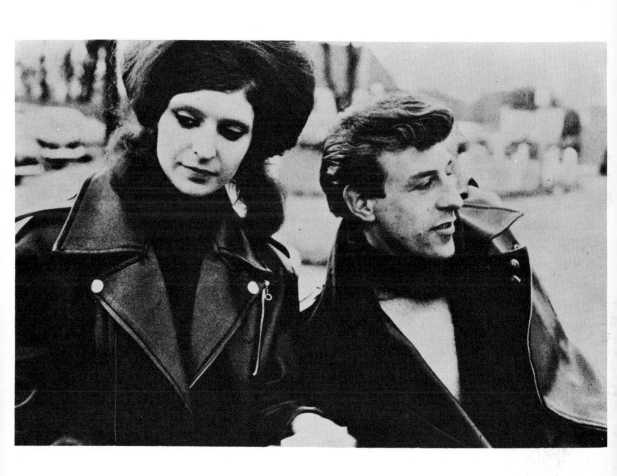

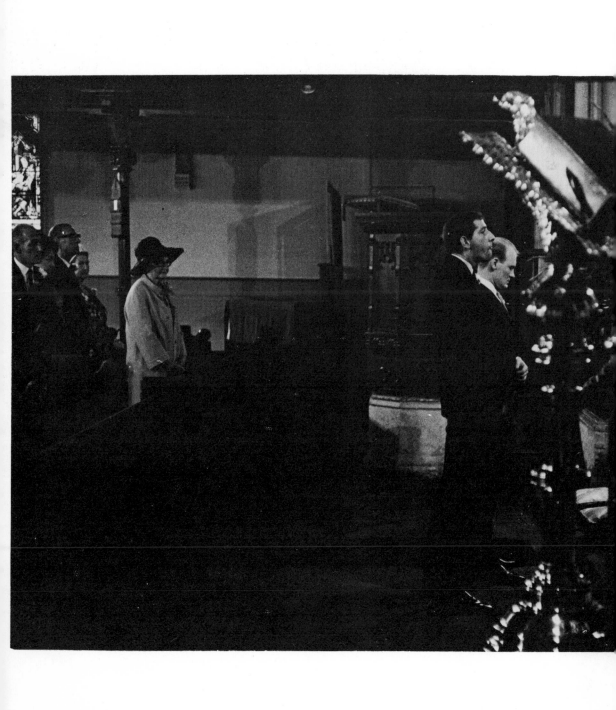

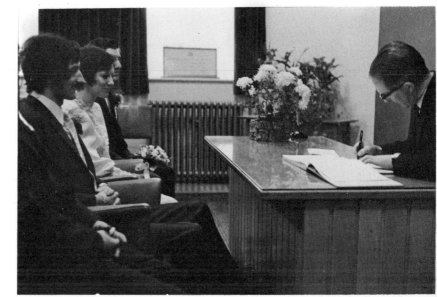

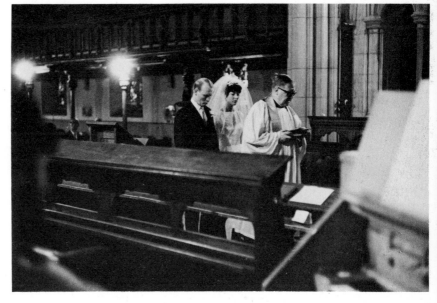

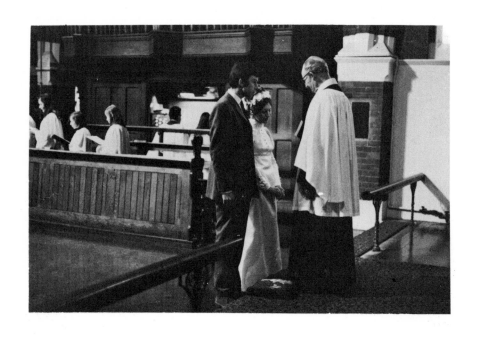

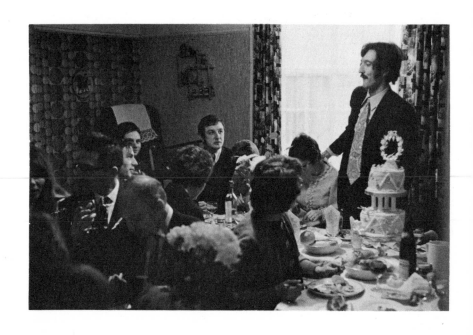

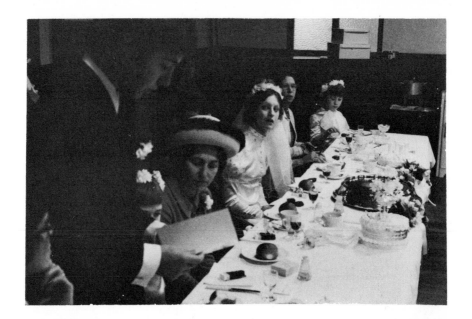

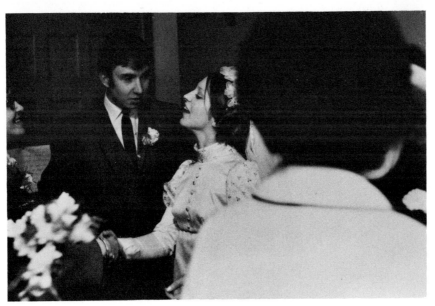

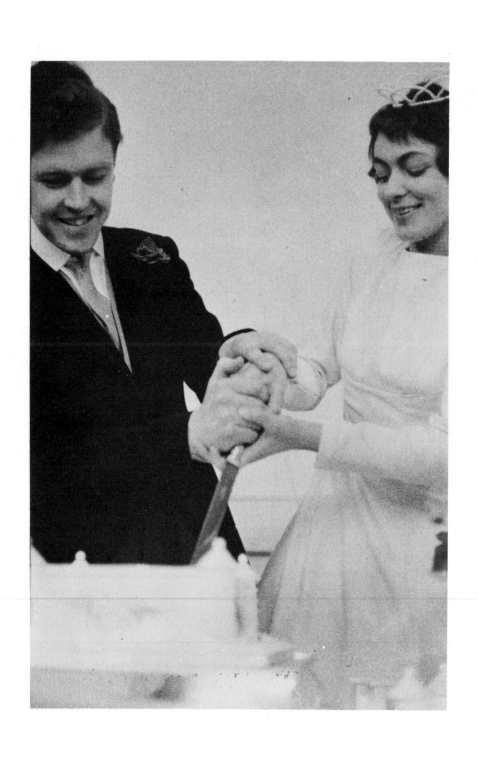

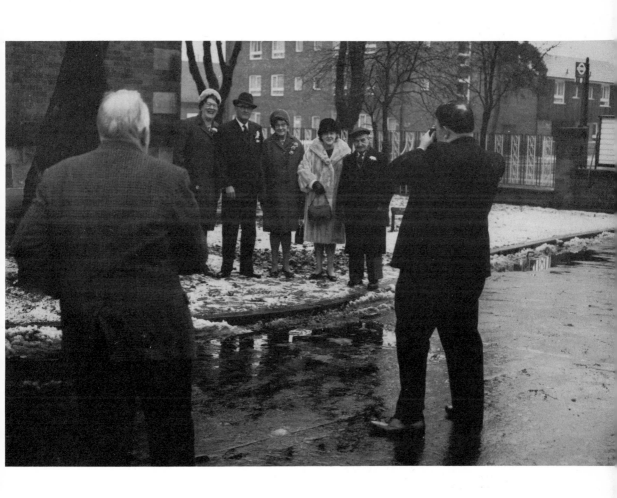

6

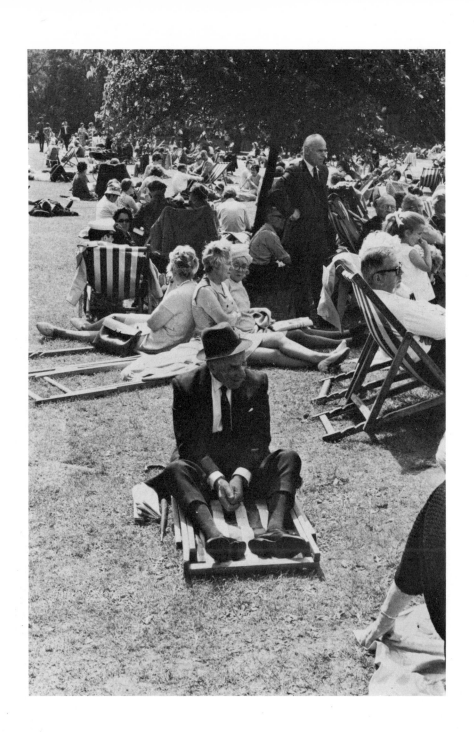

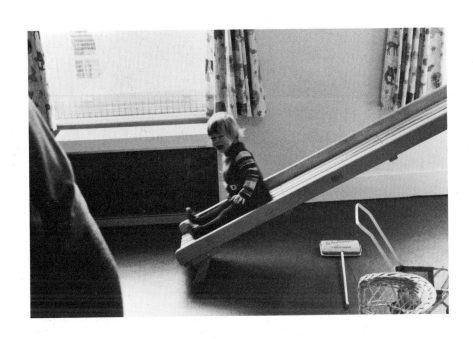

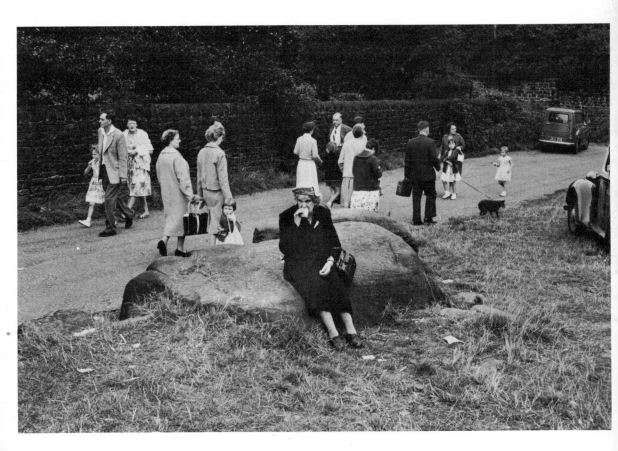

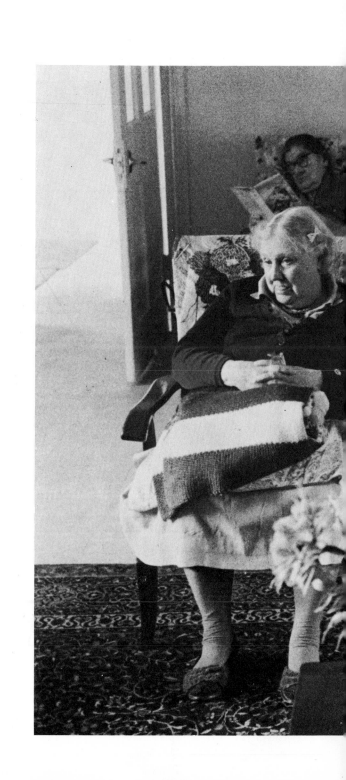

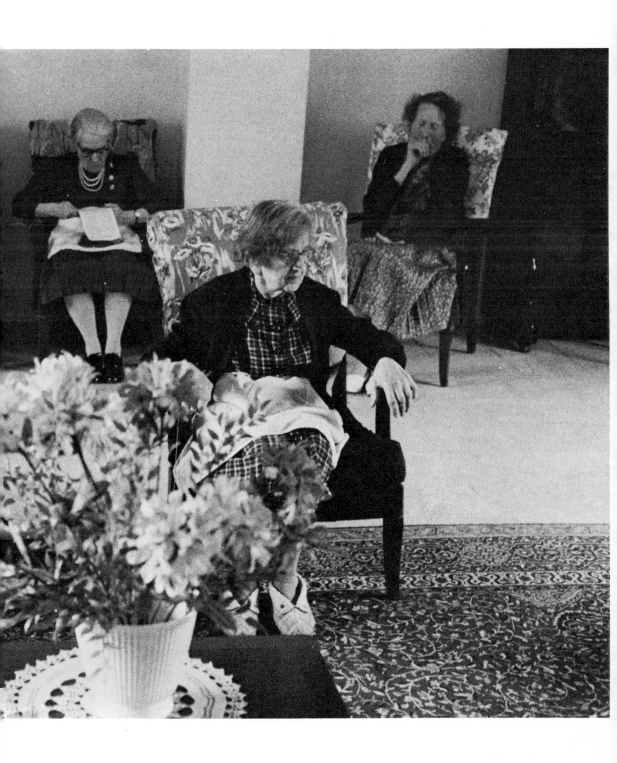

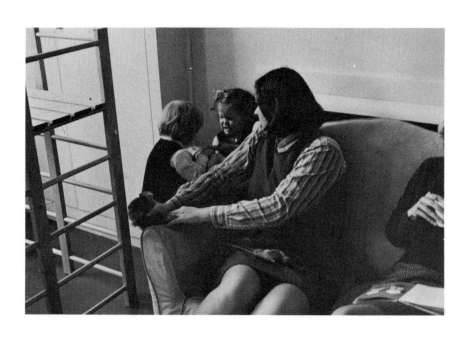

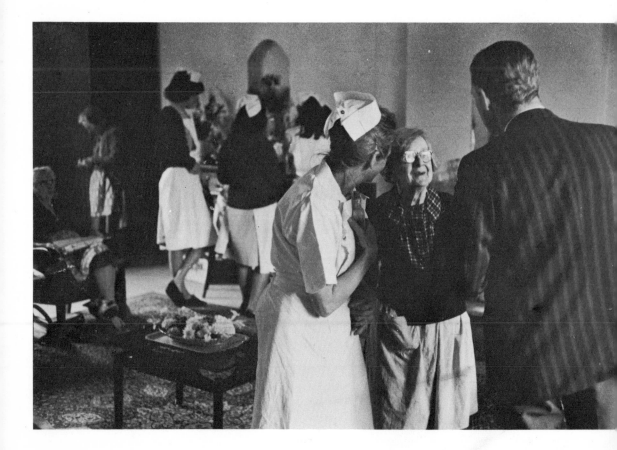

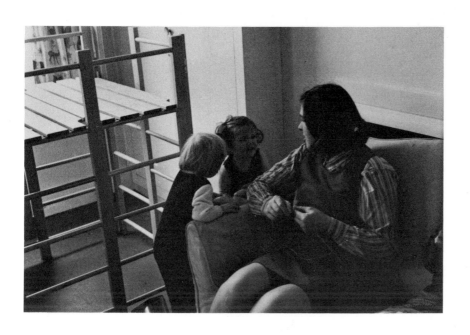

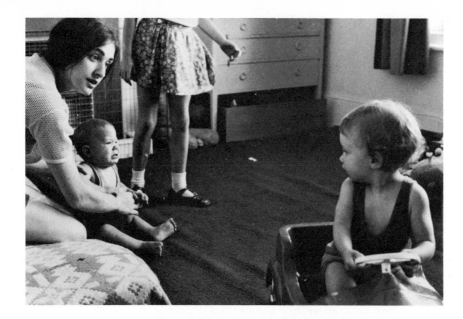

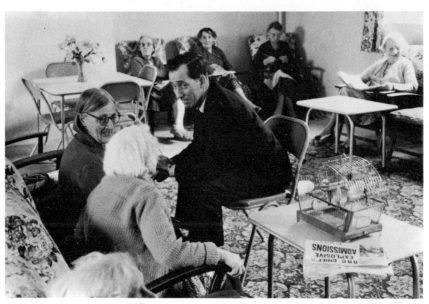

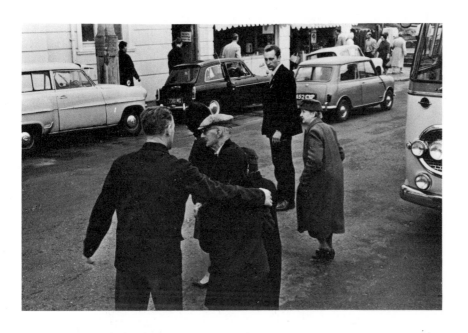

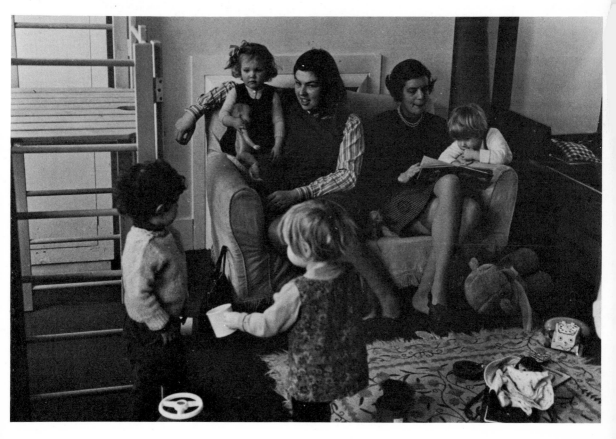

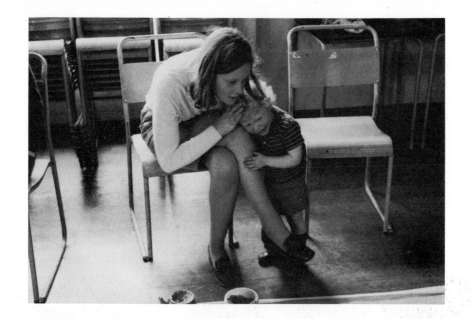

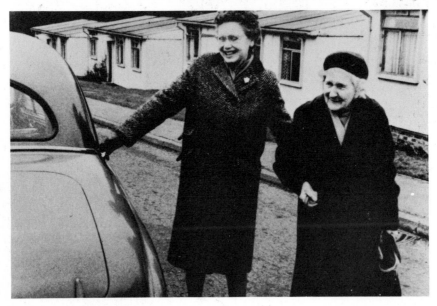

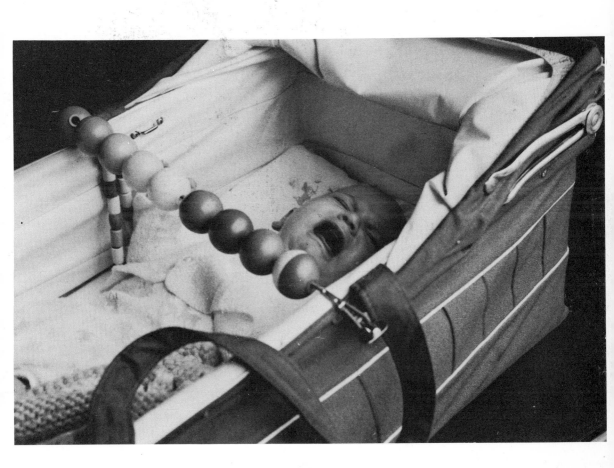

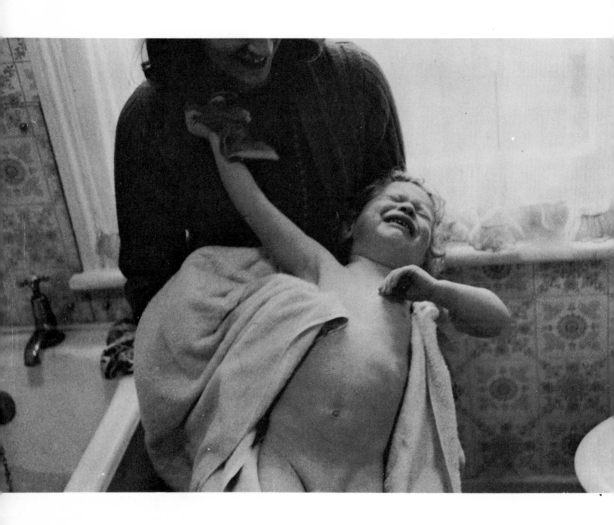